Studies in Mixed Media

Figures and Designs for the Month of March 2013

By Benjamin Long.

Illustrations by Benjamin Long for the Month of March. New Illustrations and commission work that was requested of me. Many pieces feature the cartoon/ cross hatch style that I have been working on as well as a few underpaints.

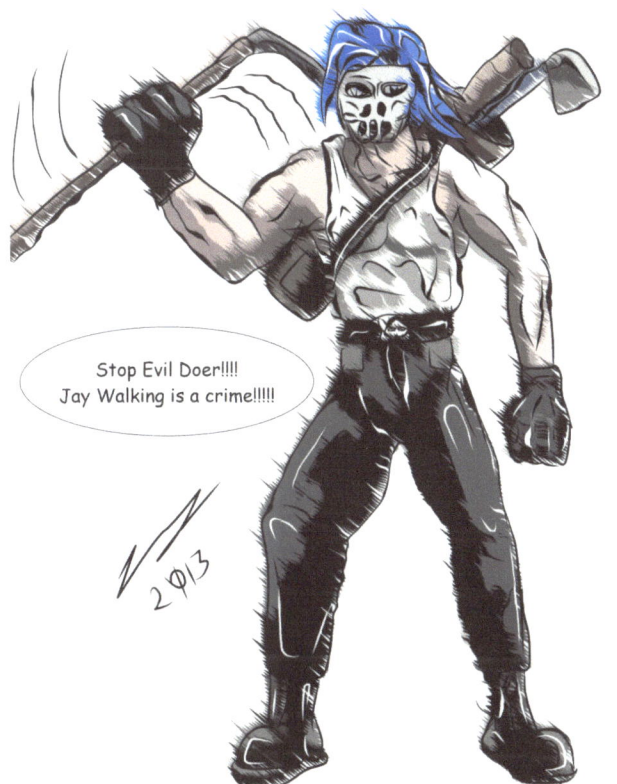
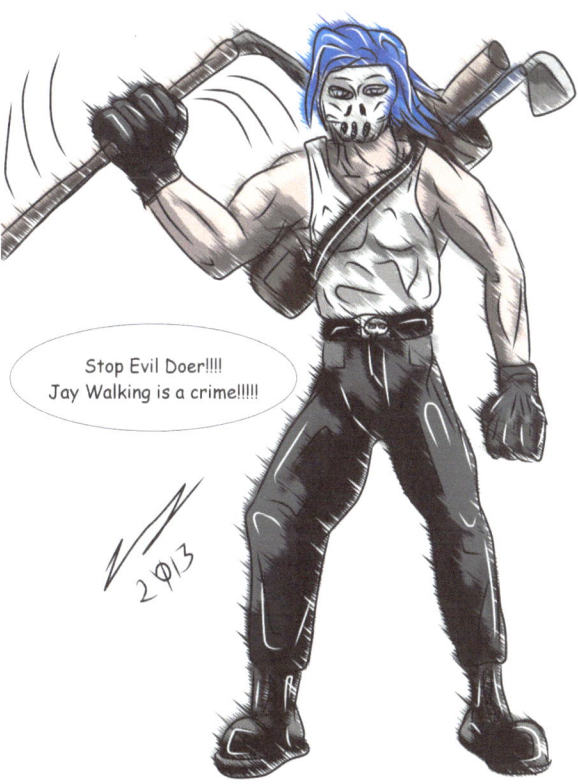

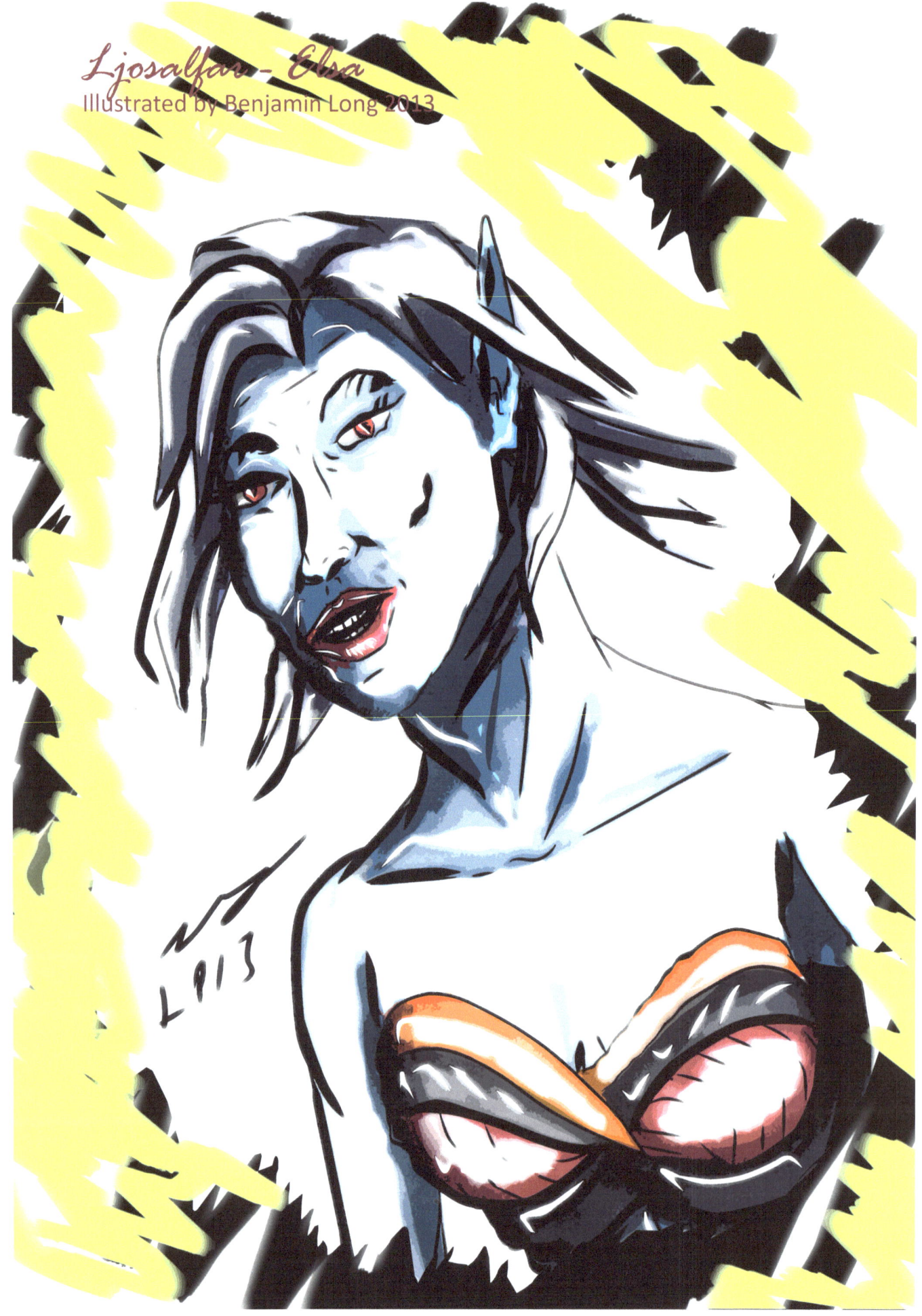

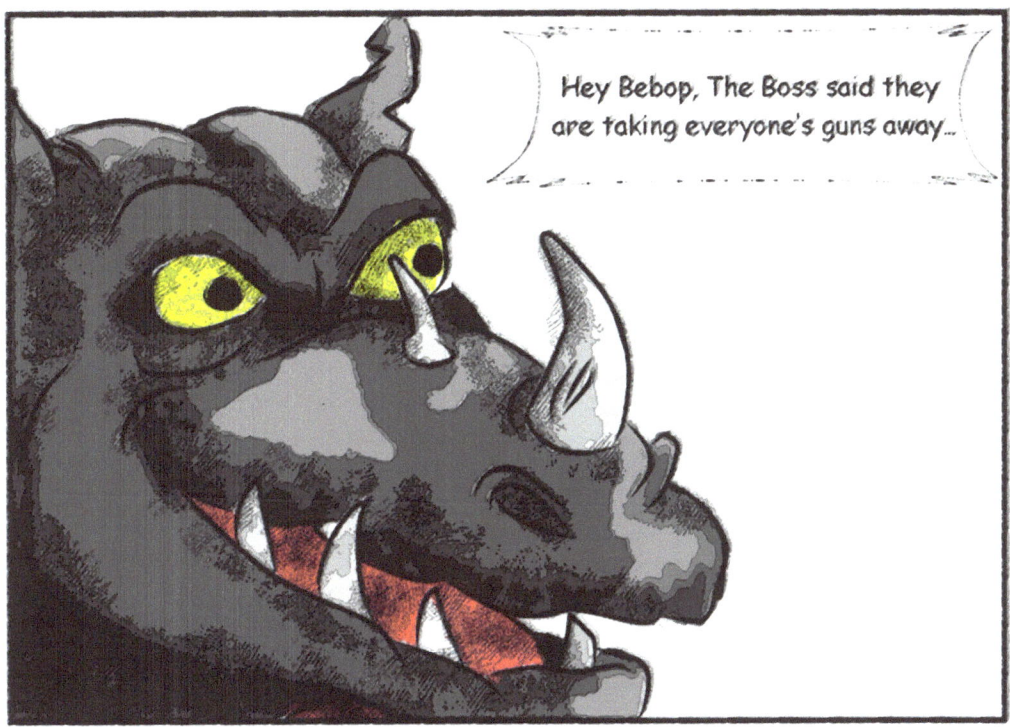
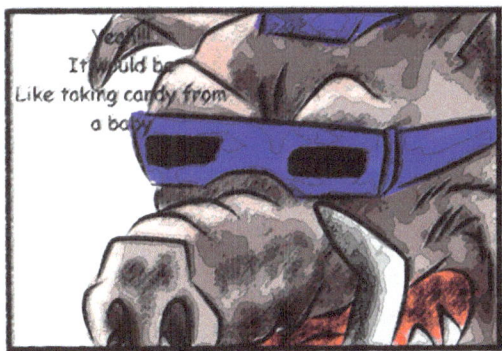
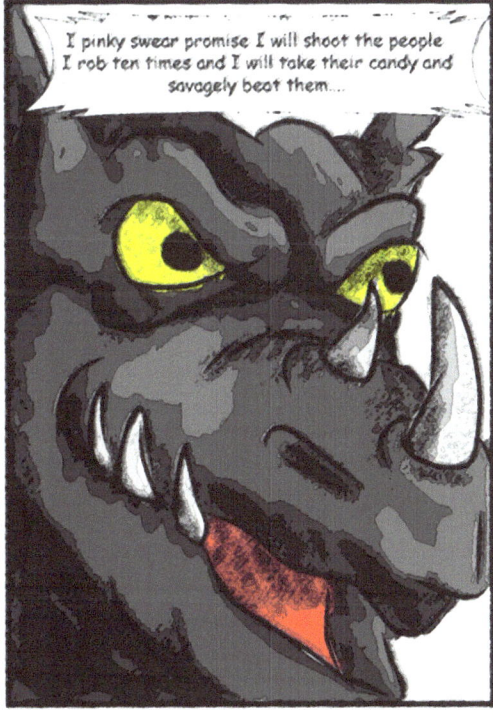

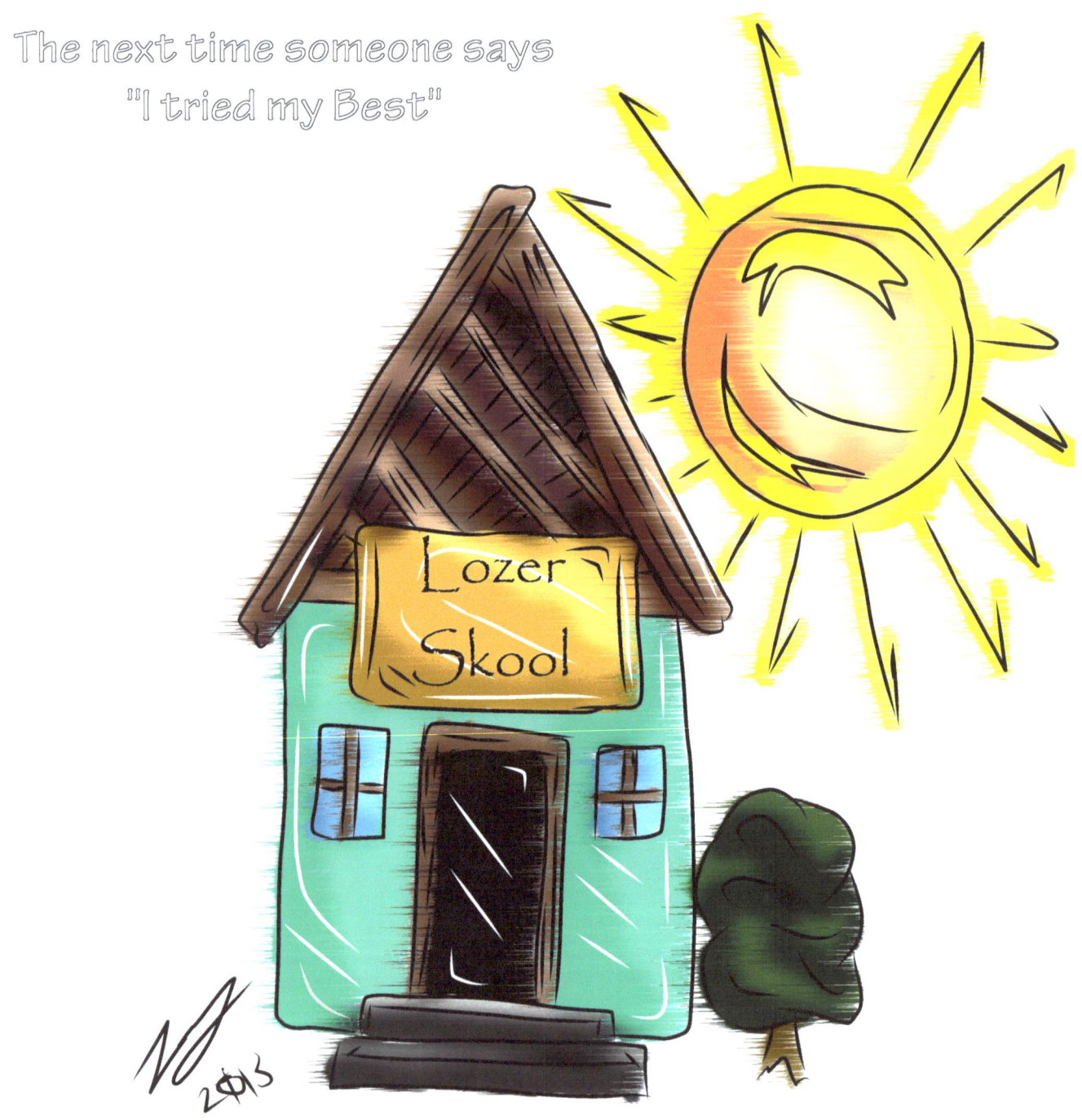

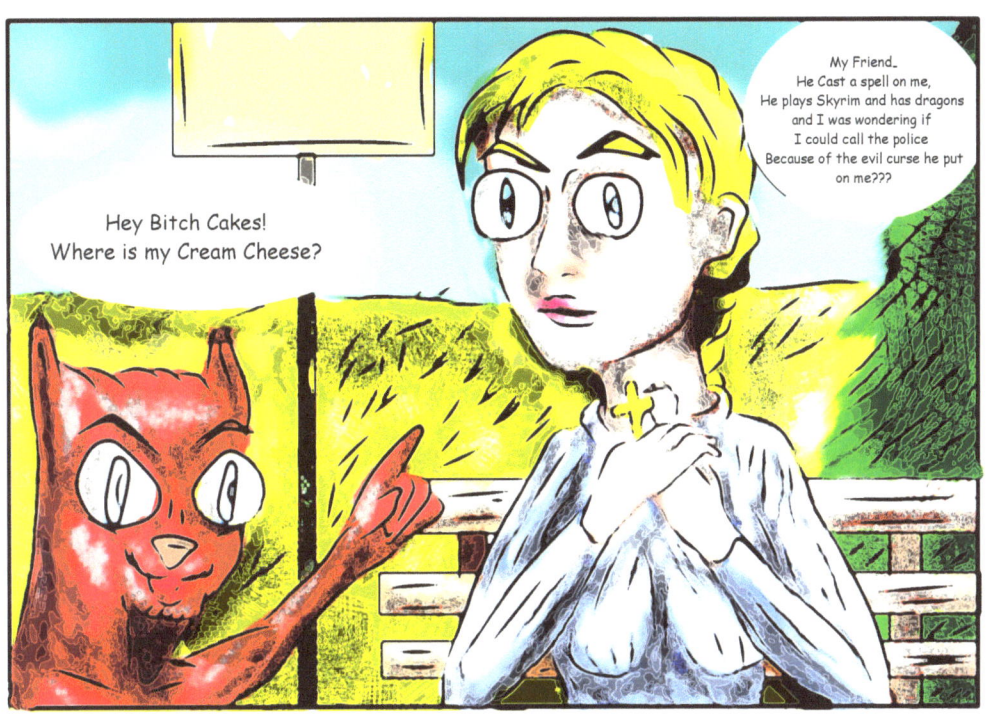
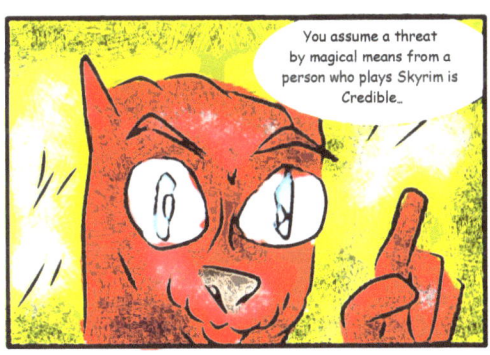
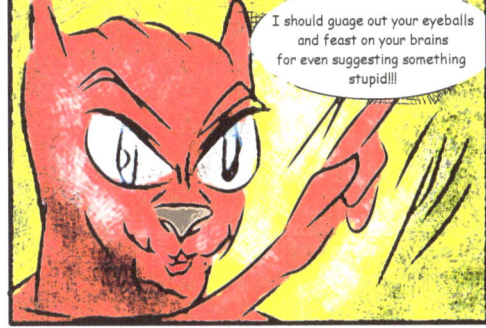
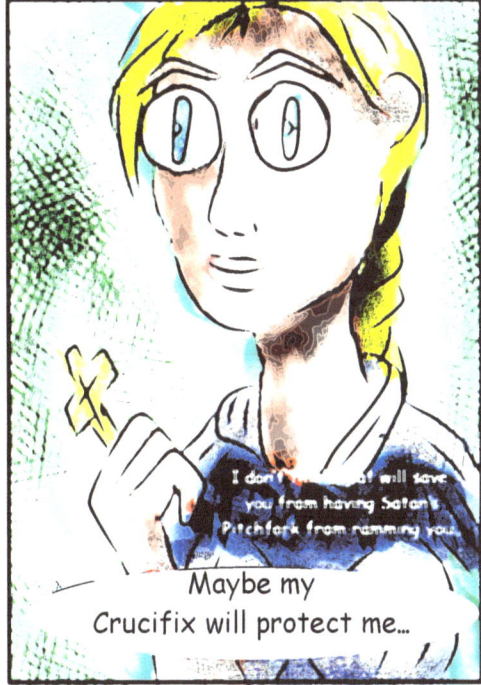

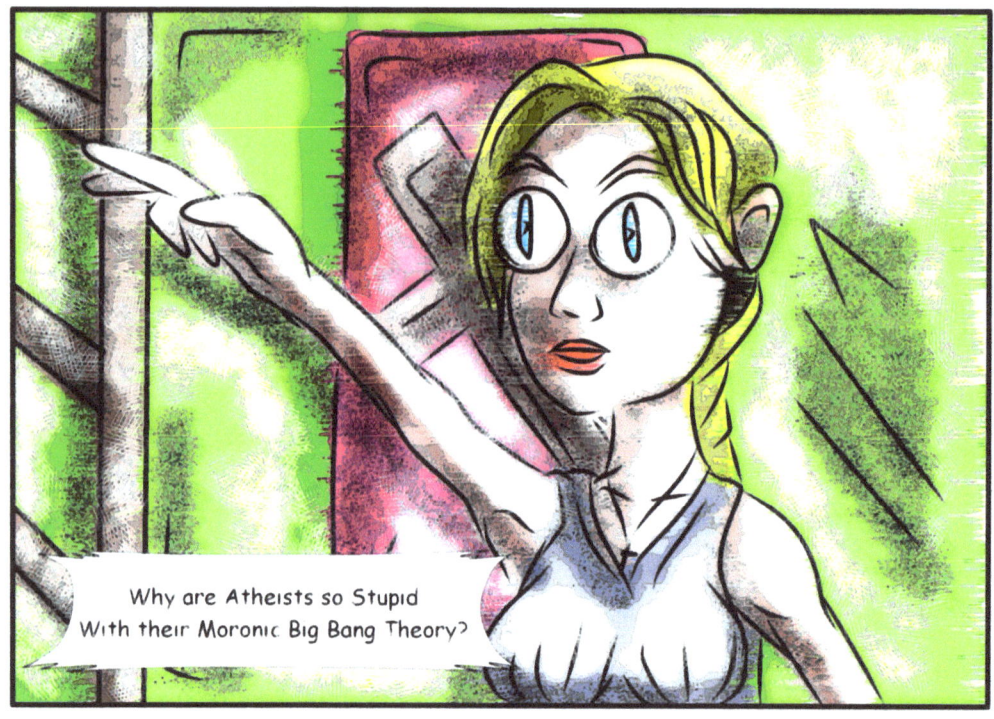
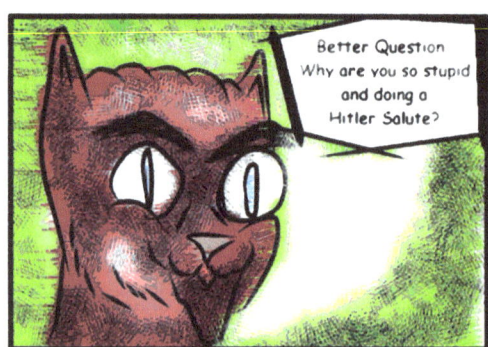
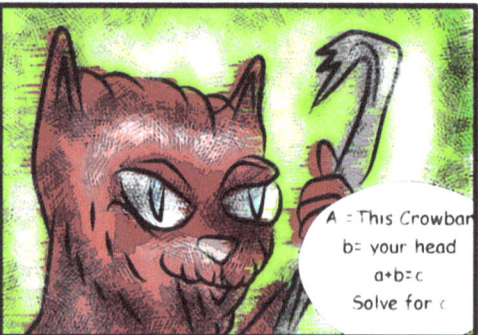
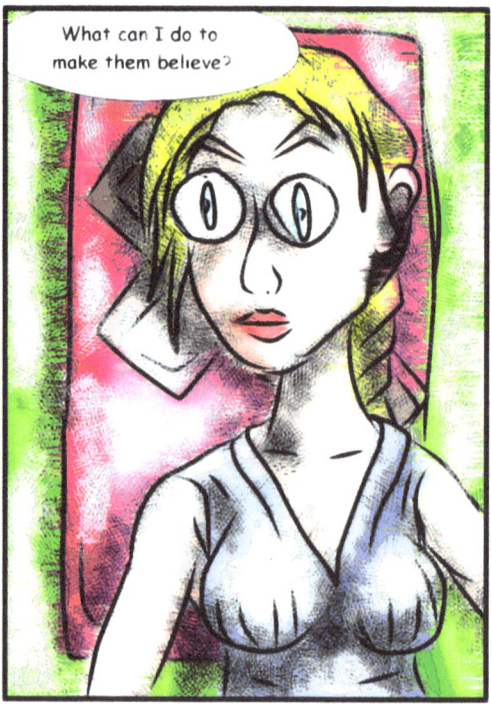

Mutant Girls -- TMNT
Illustrated by Benjamin Long 2013

Venus - April - Mona

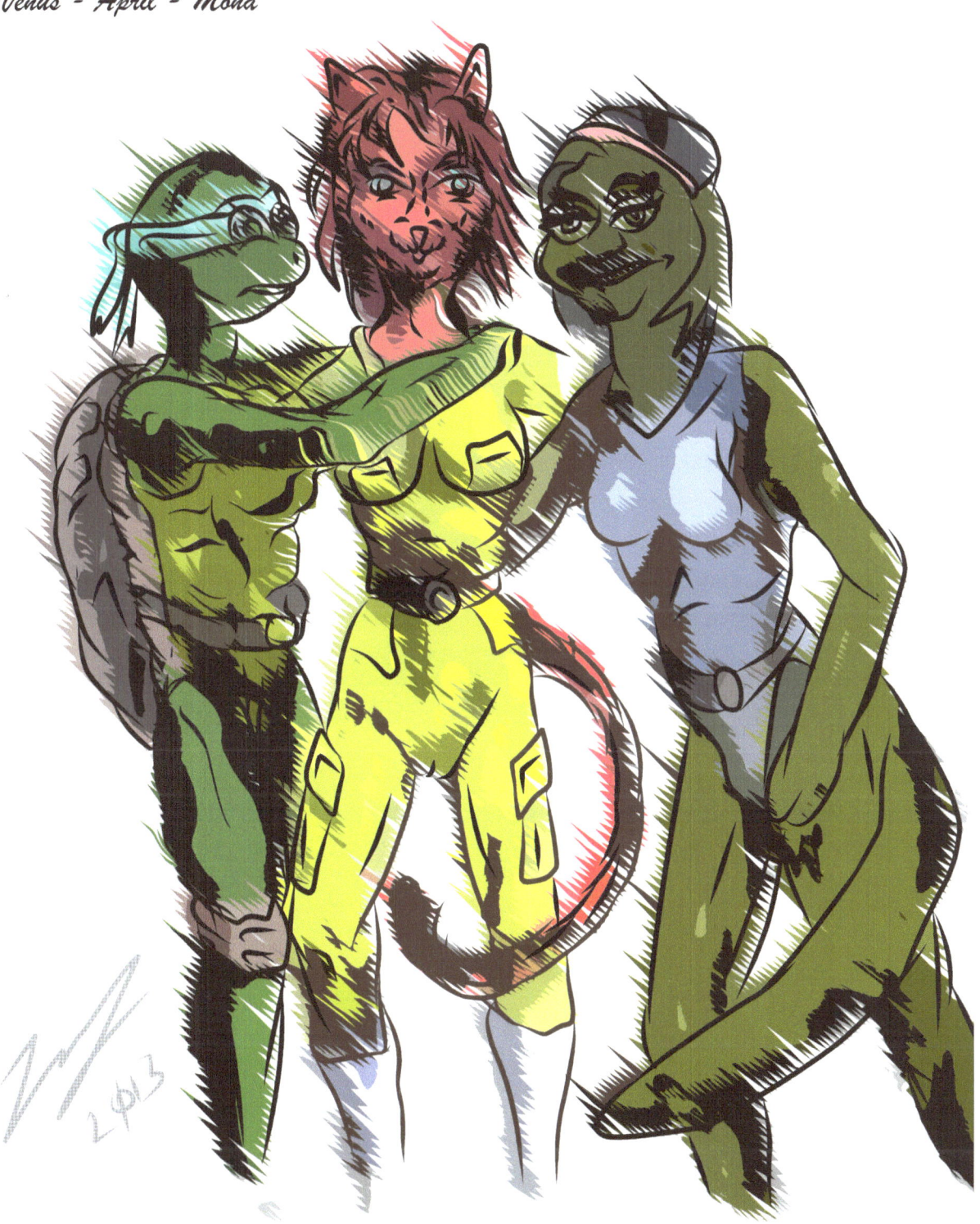

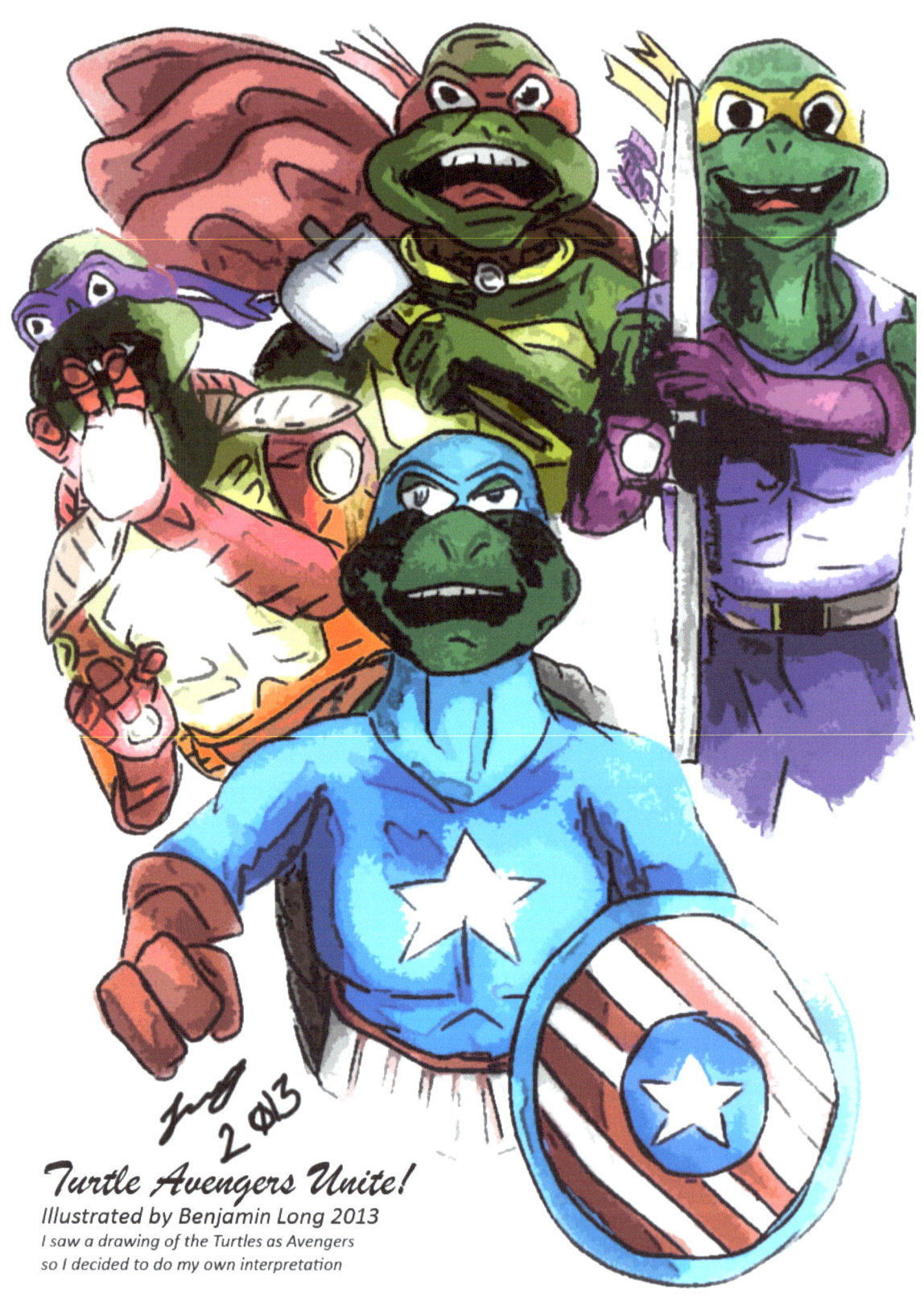

Turtle Avengers Unite!
Illustrated by Benjamin Long 2013
I saw a drawing of the Turtles as Avengers
so I decided to do my own interpretation

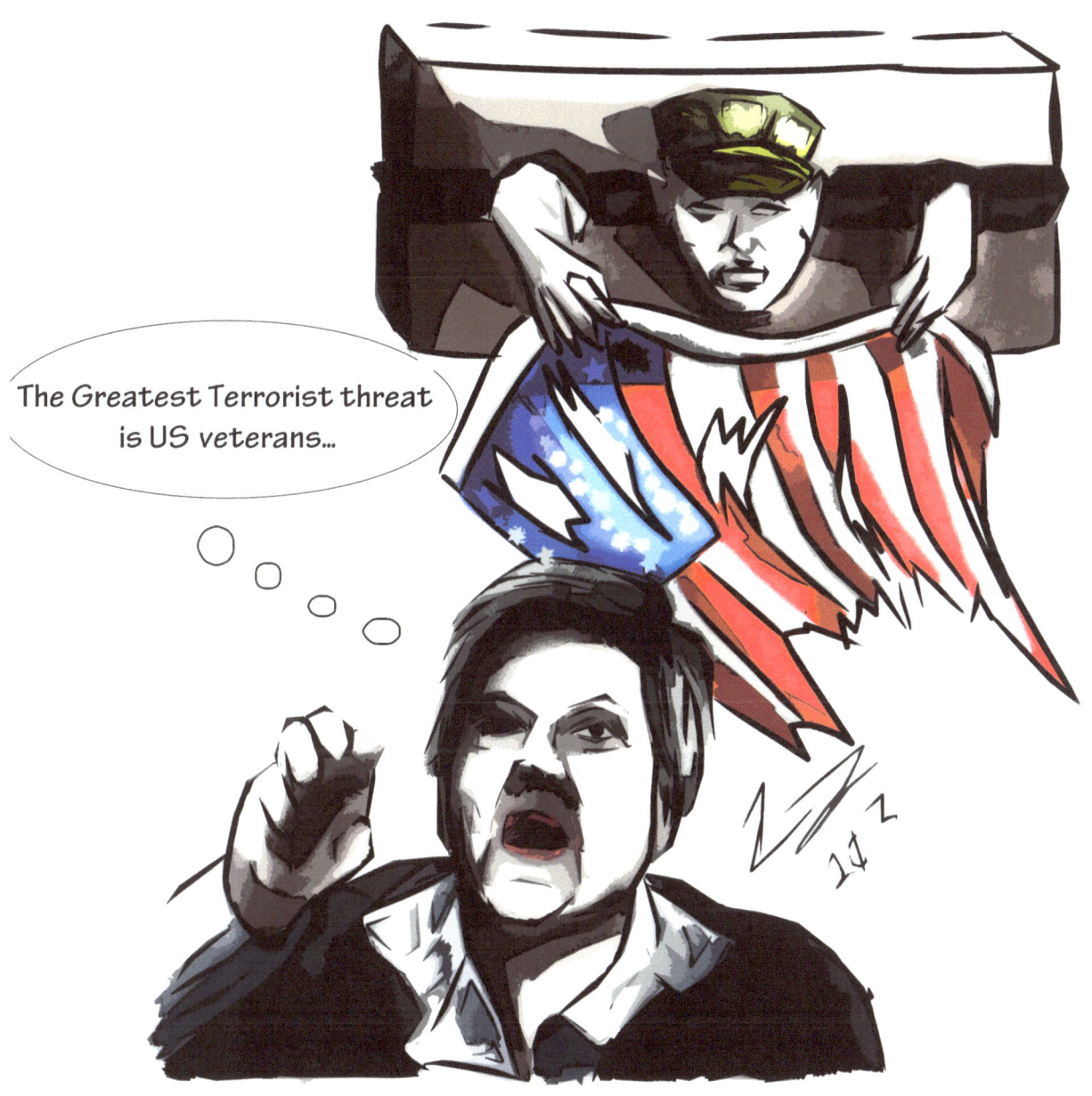

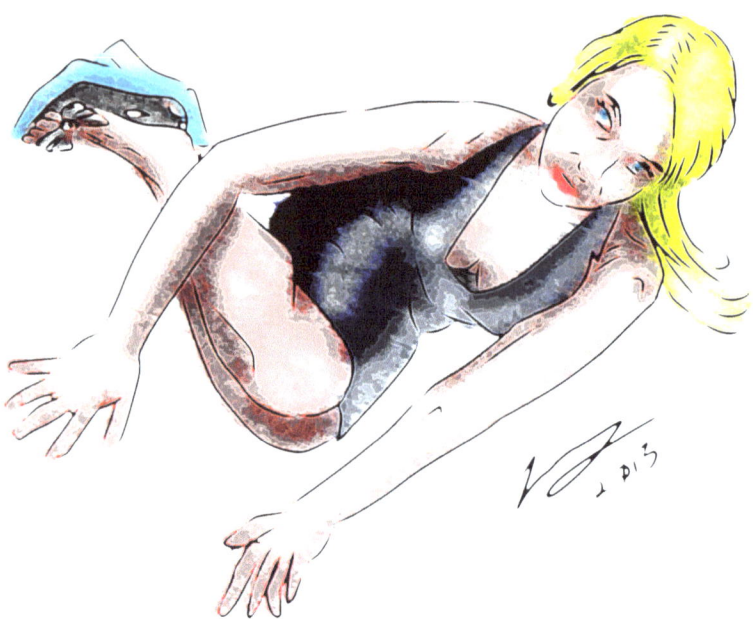

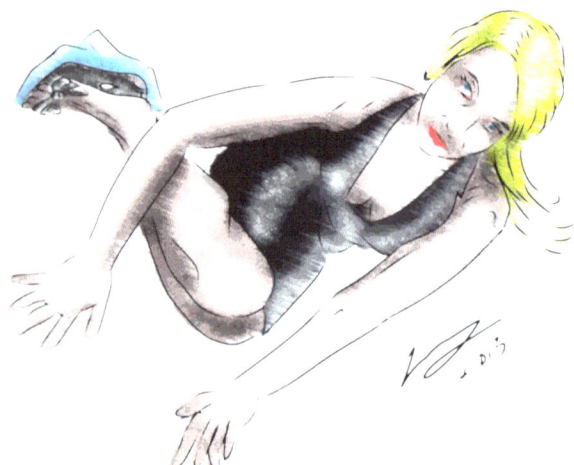
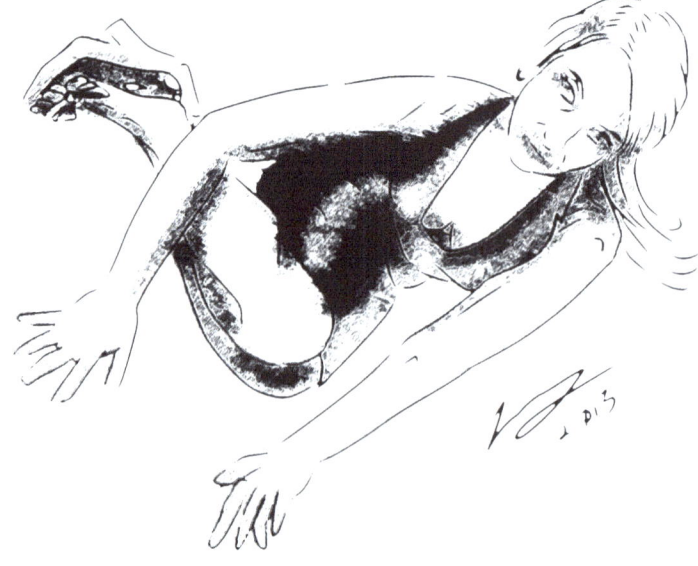

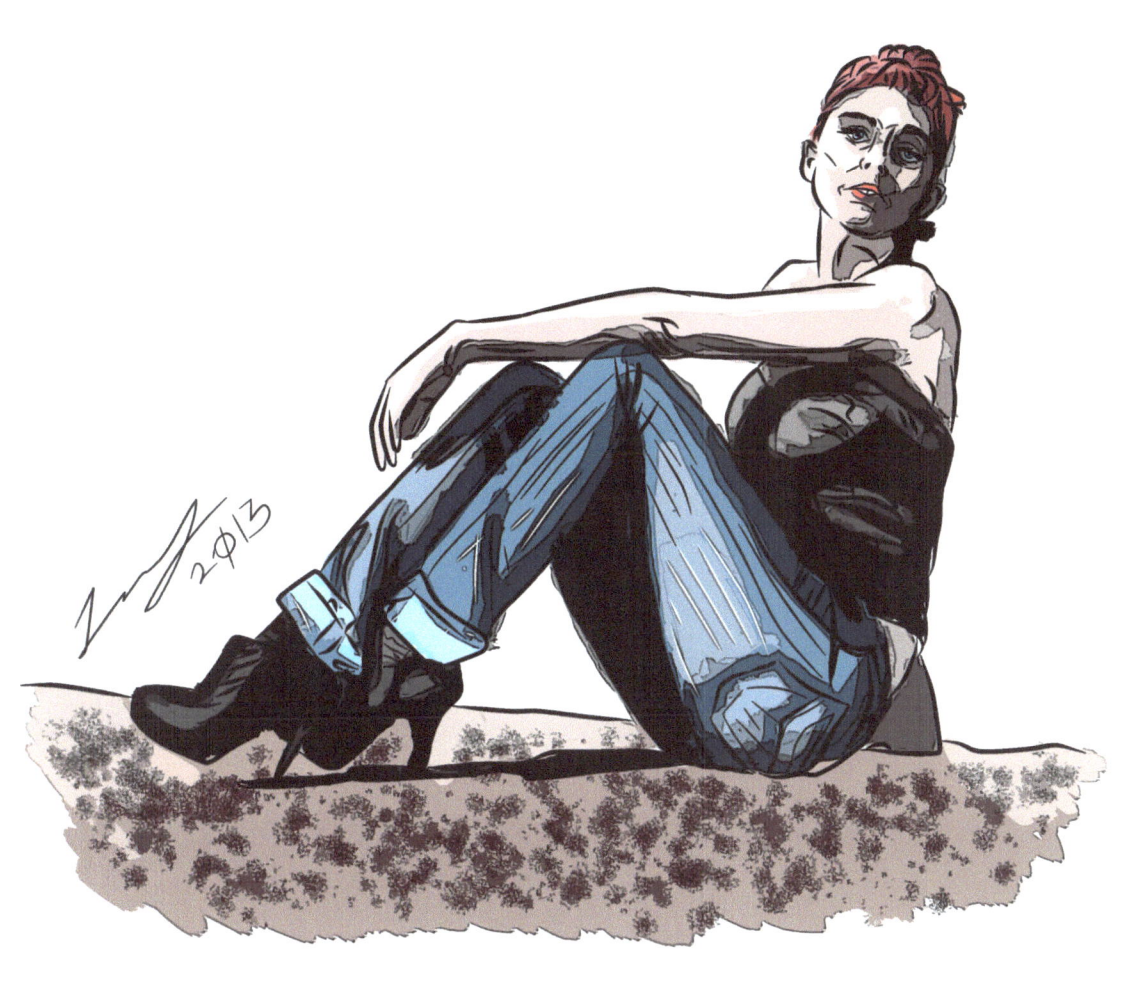
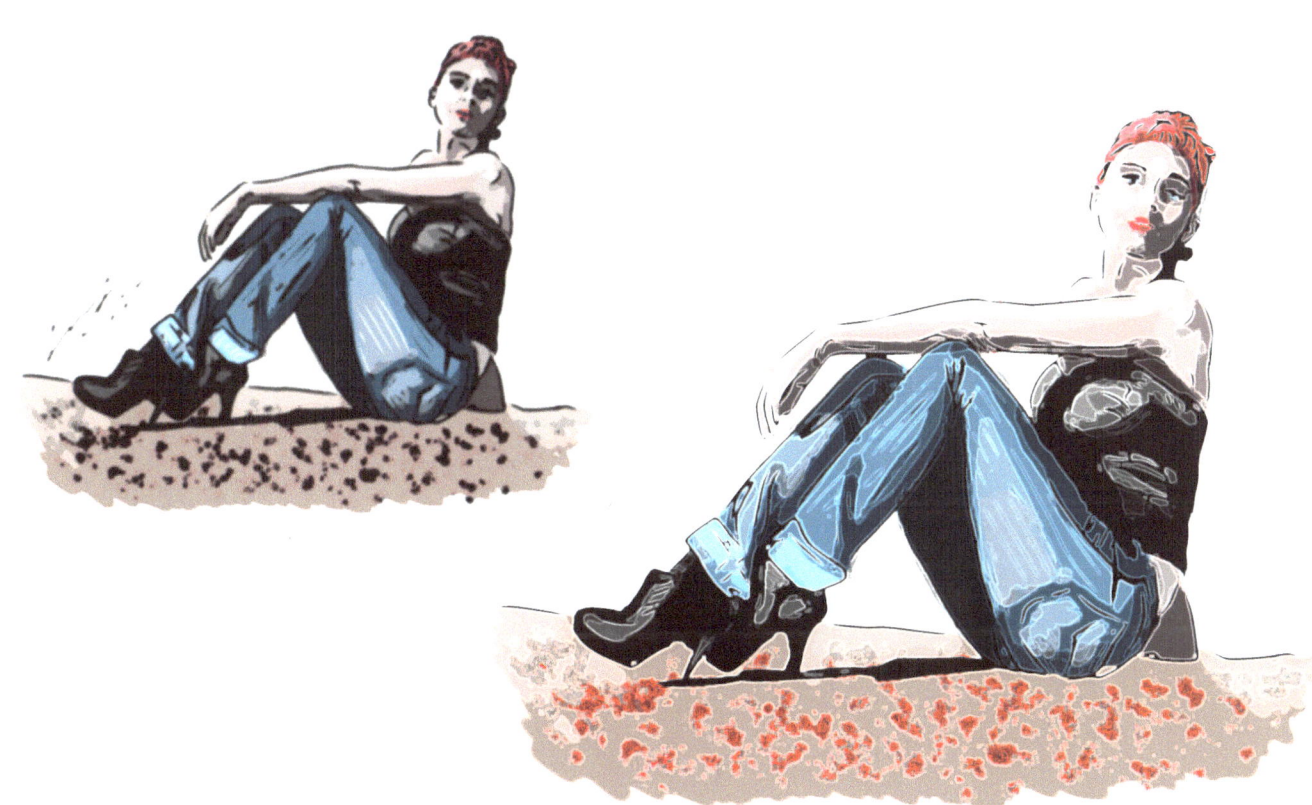

Ready for Battle

Referenced from Stock photo by Mjranum
Illustrated by BenjaminLong 2013

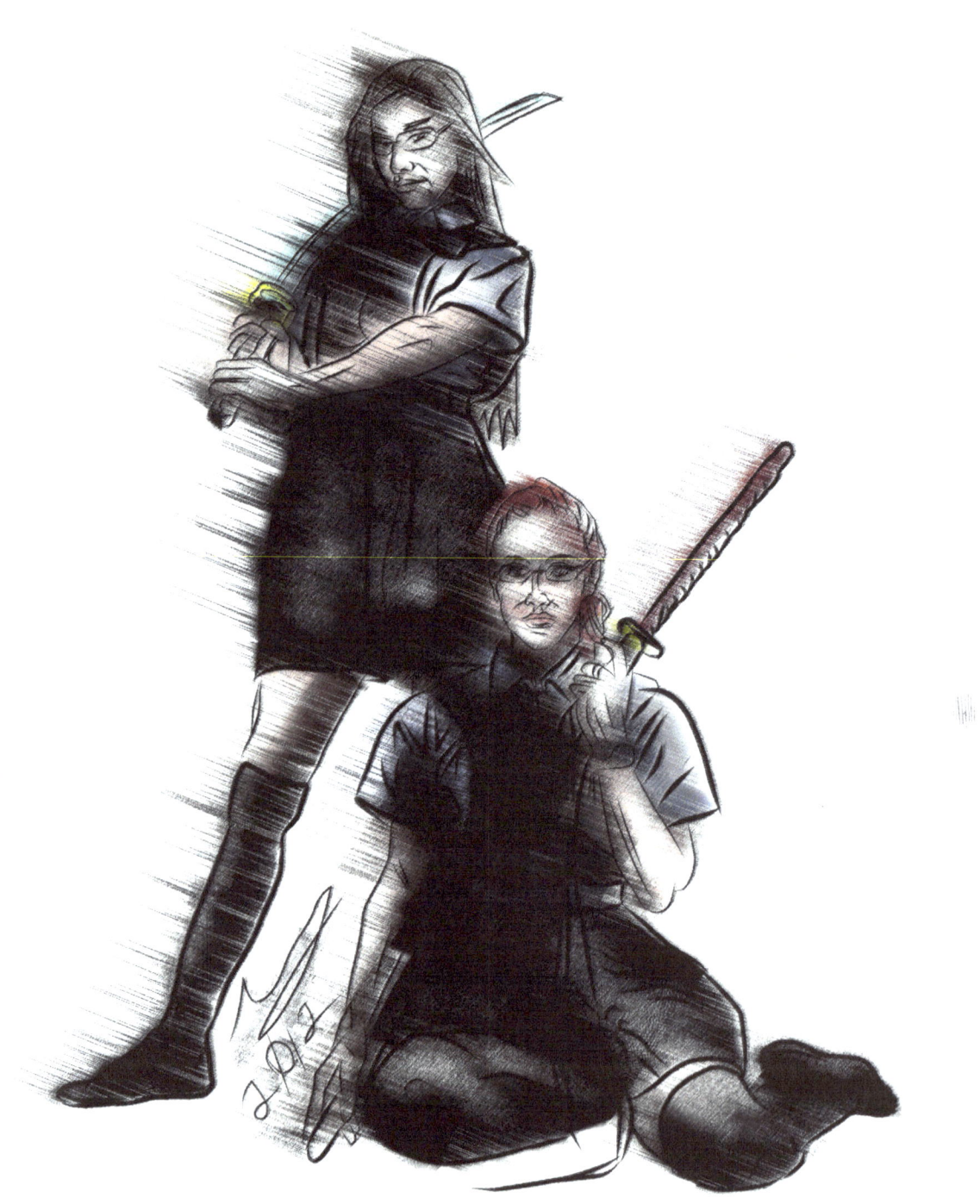

Catherine

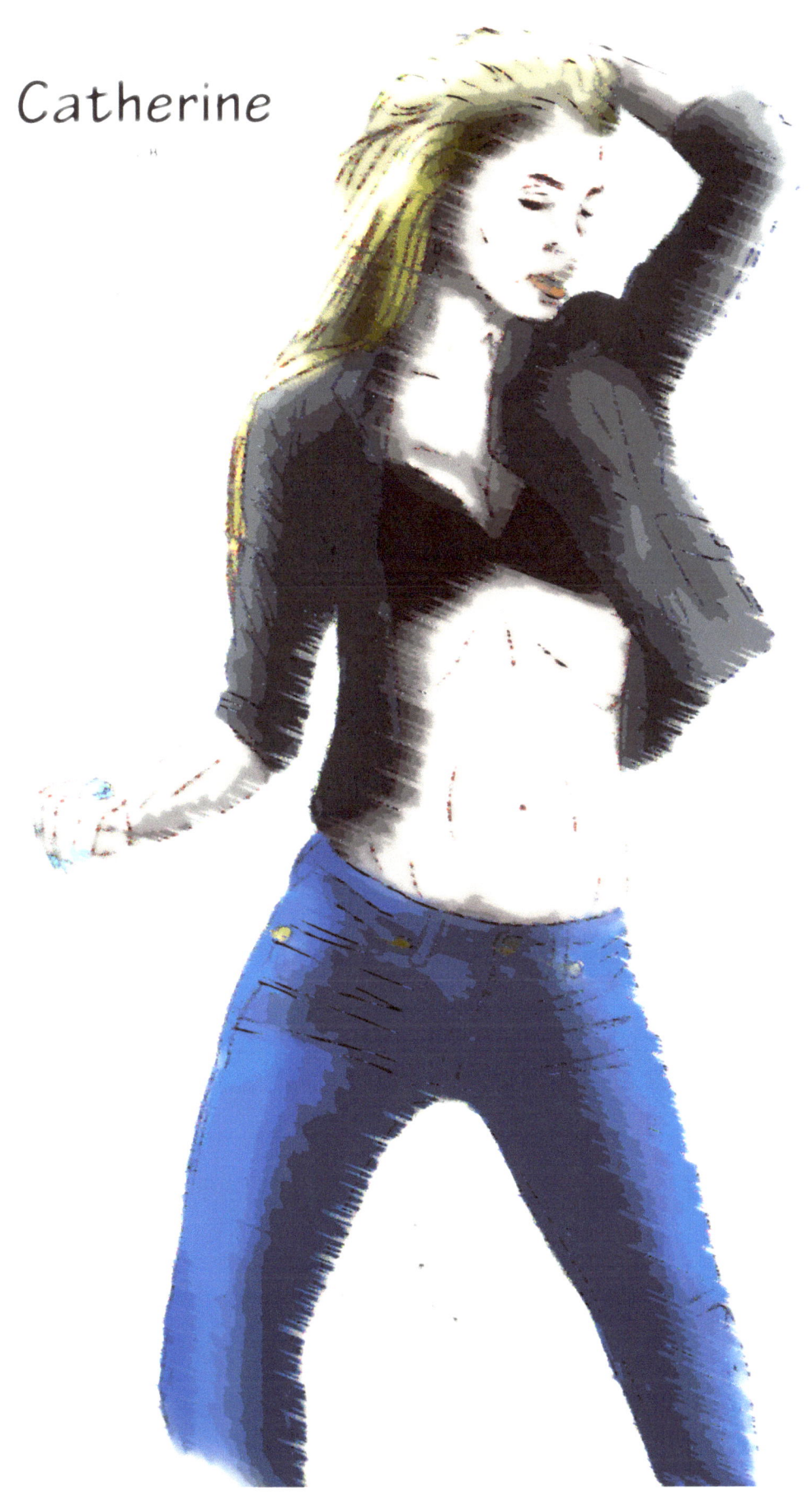

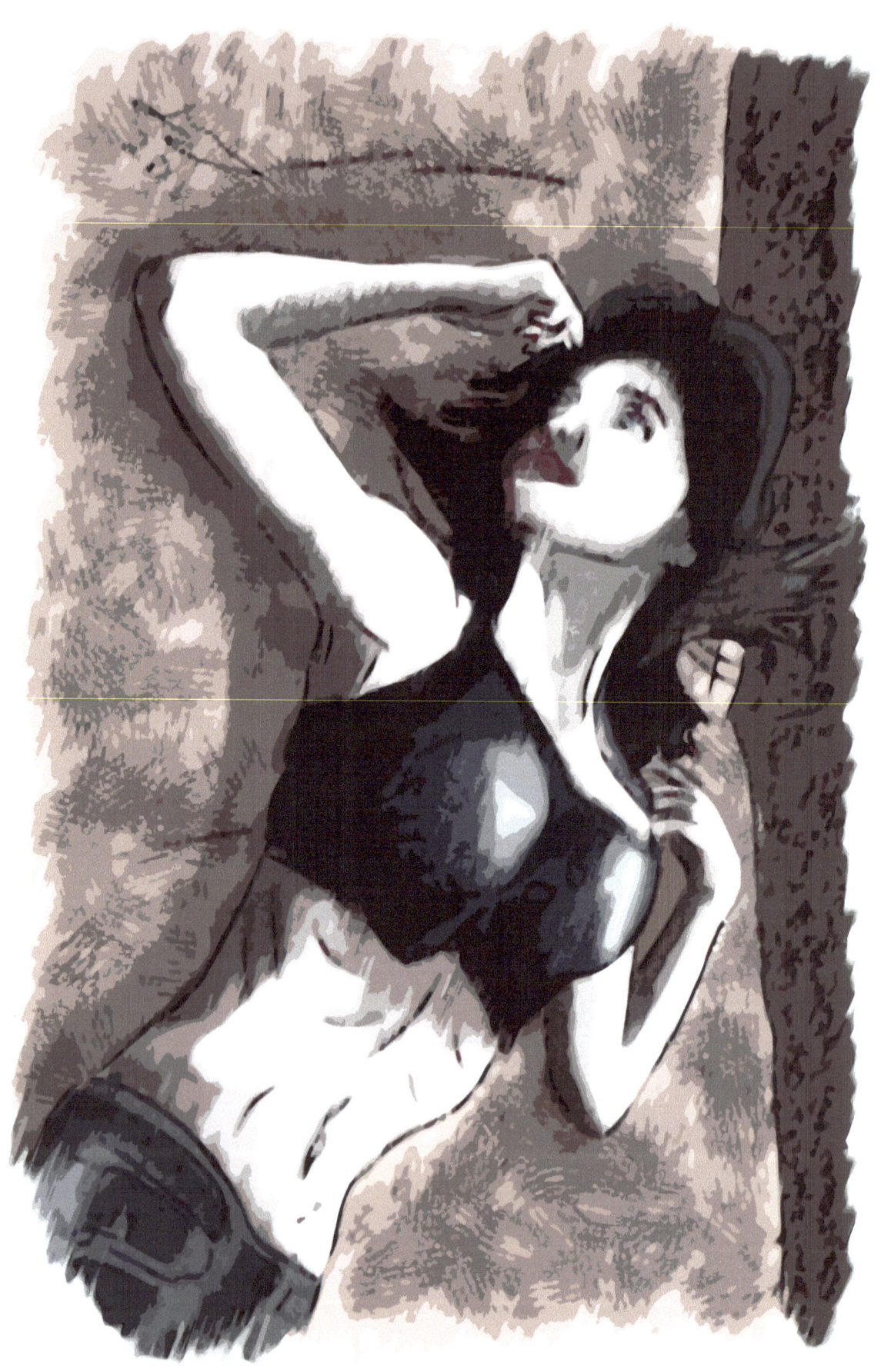

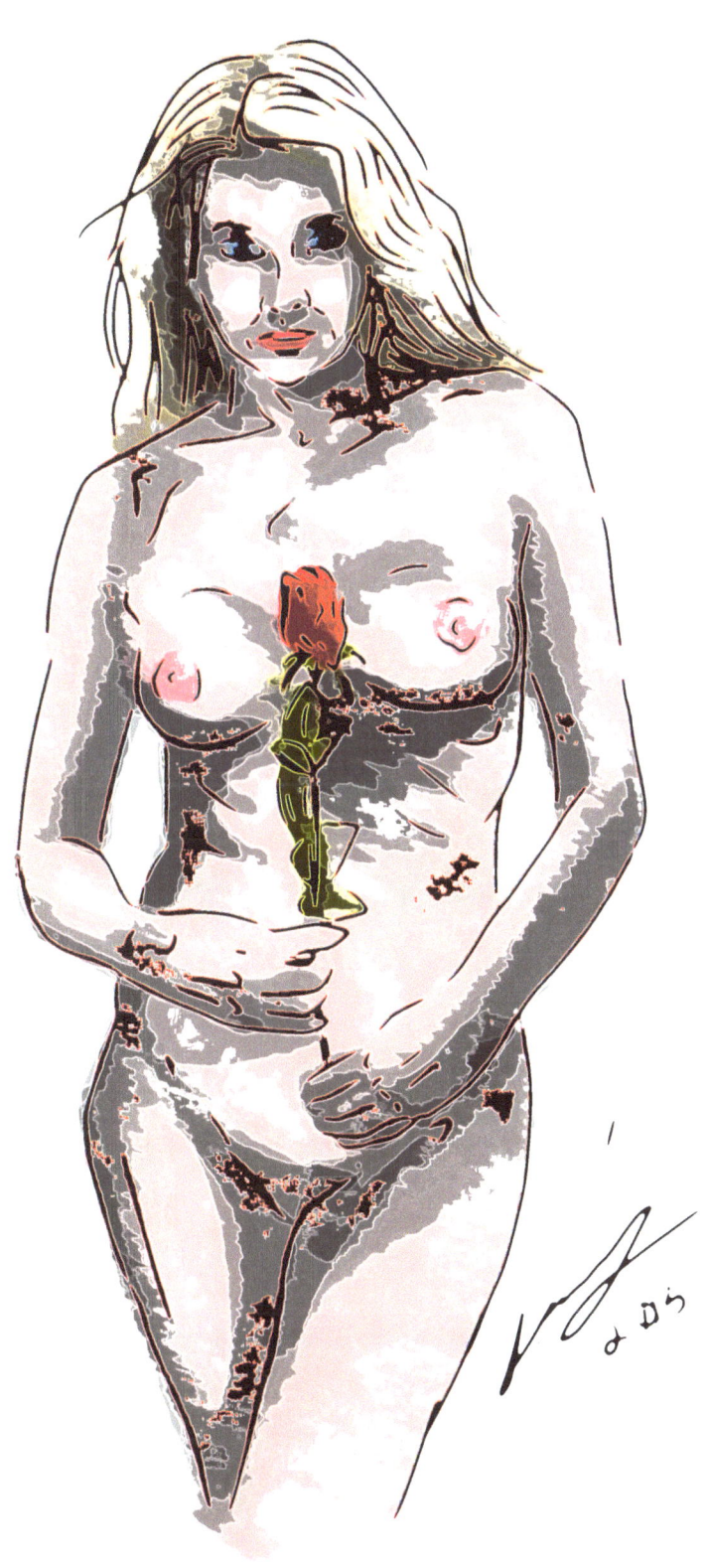

You think if we shoot the corpses 150 more times, it will stop their corpses coming back as zombies???

CSI with ungloved hand

Security Vehicle within Possible blast range of possible IED

Possible Compressed Gas Canisters in line of fire.

Tree Sparrow
By Benjamin R Long 2013

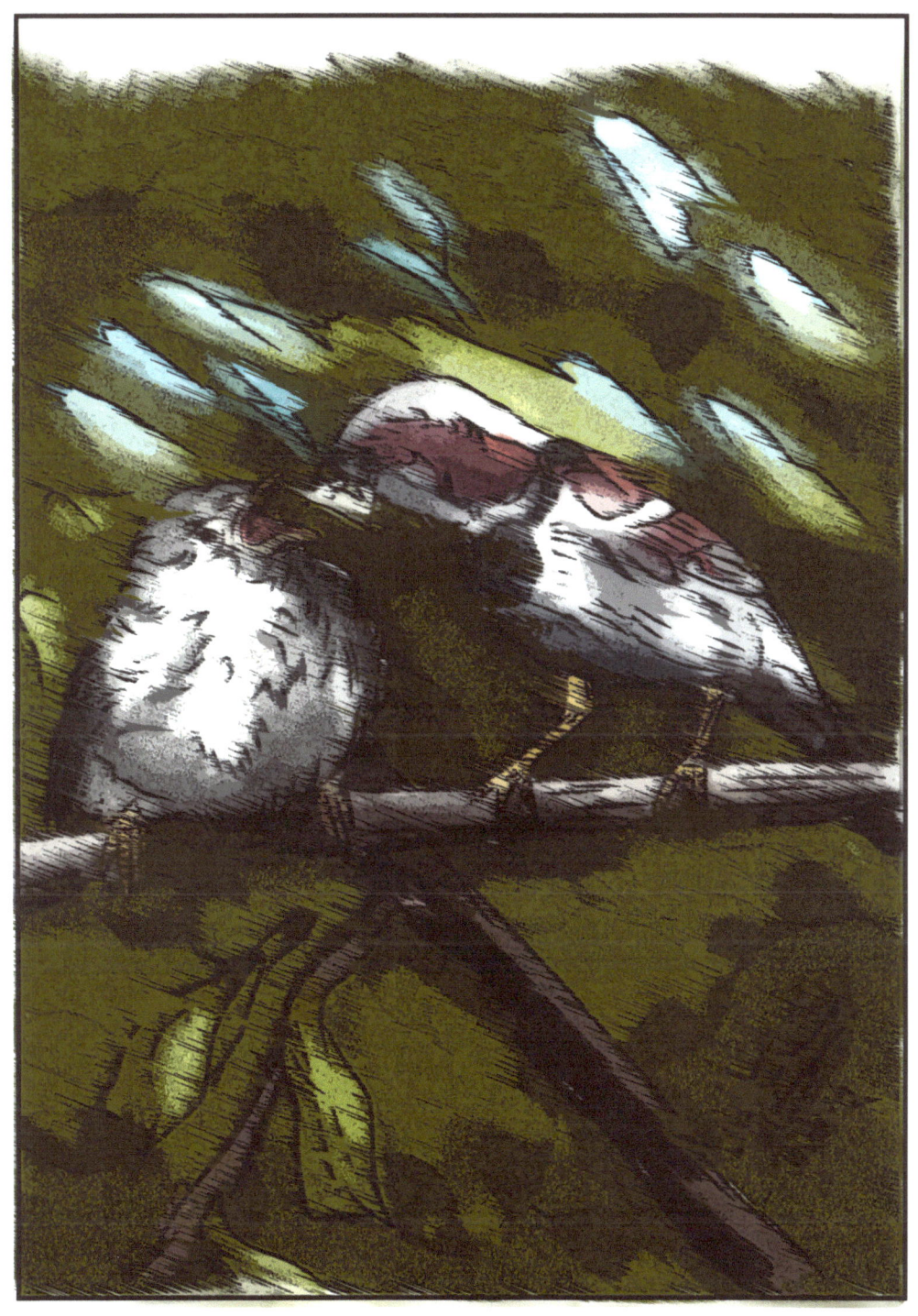

Pot and Kettle
By Benjamin Long

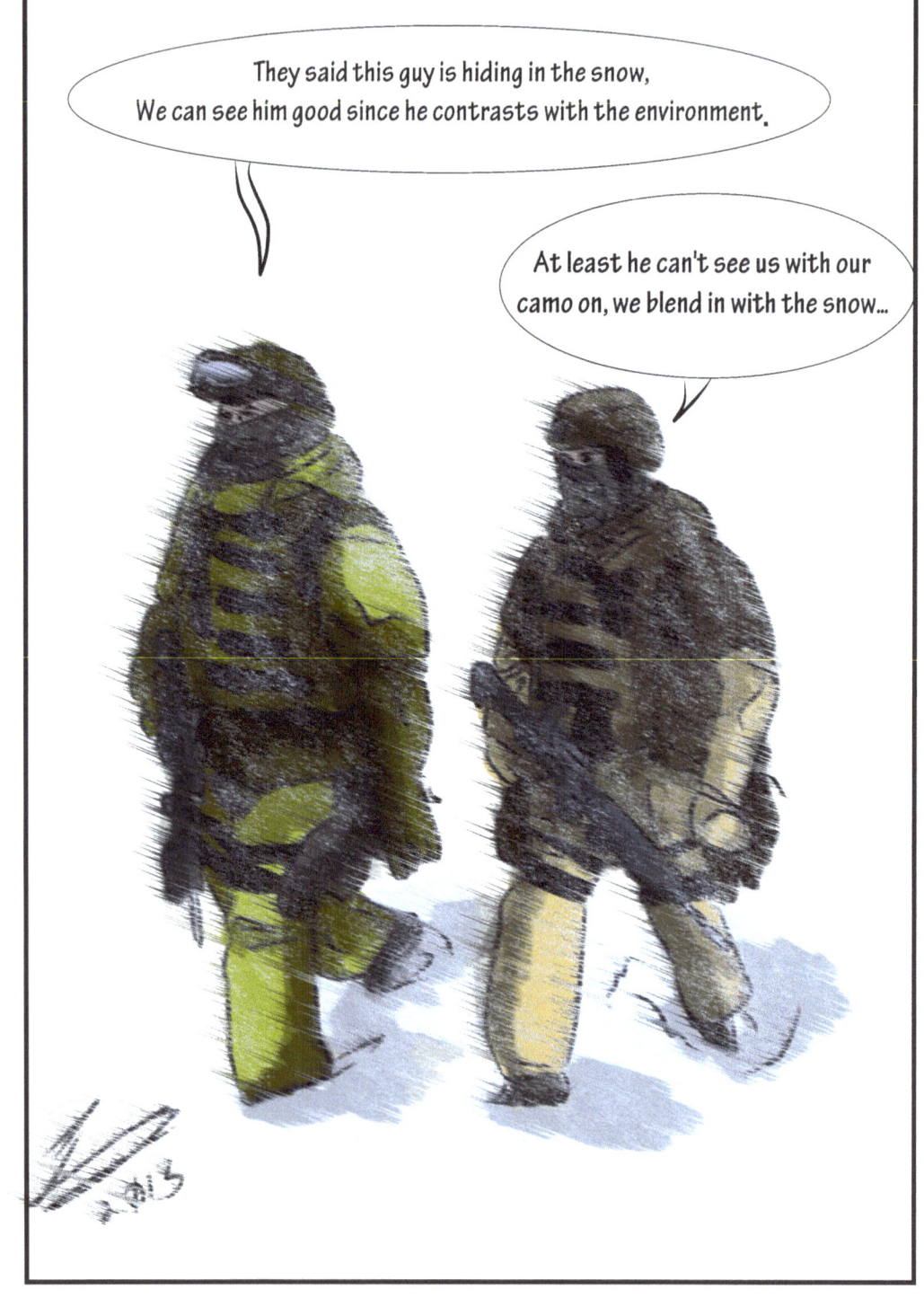

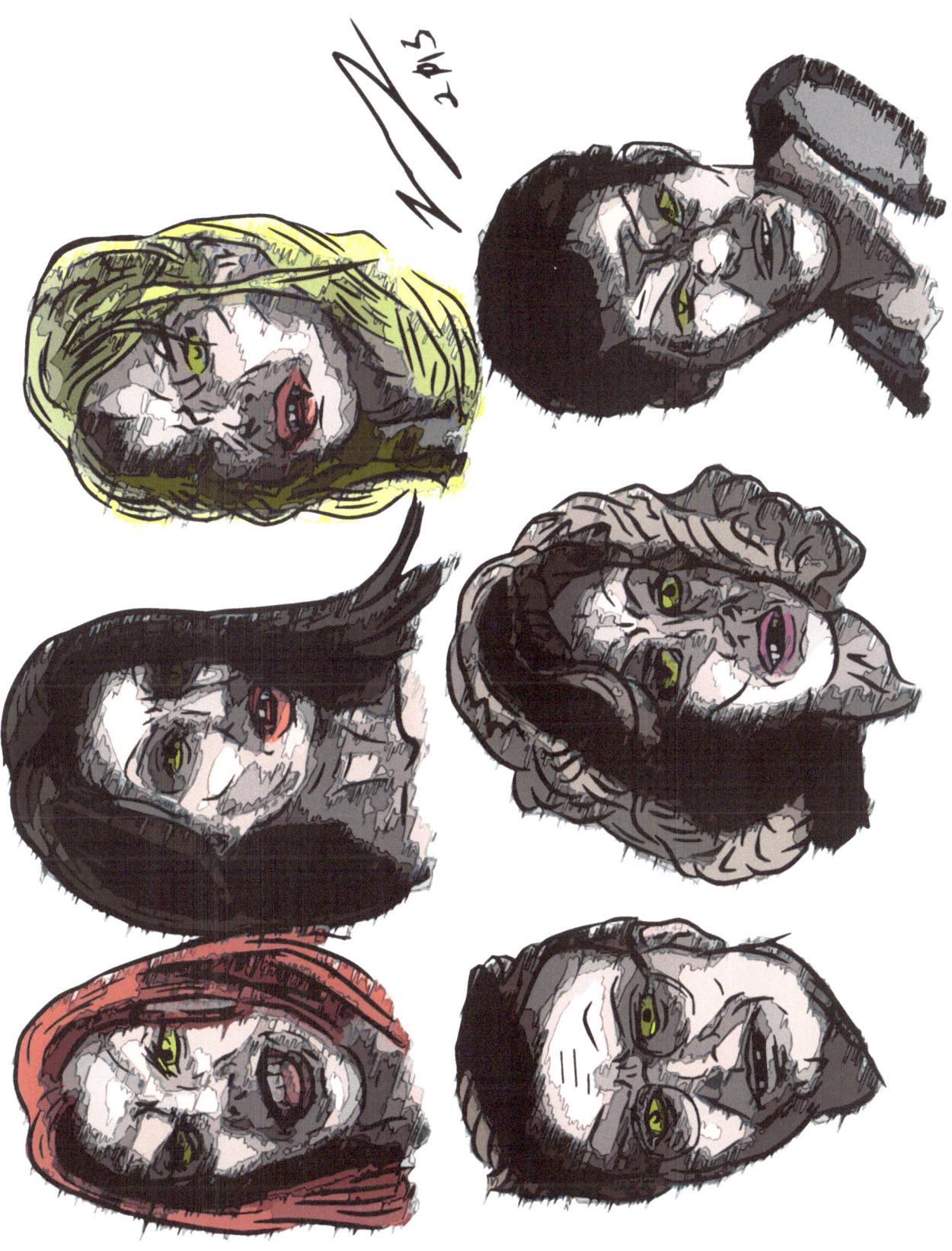

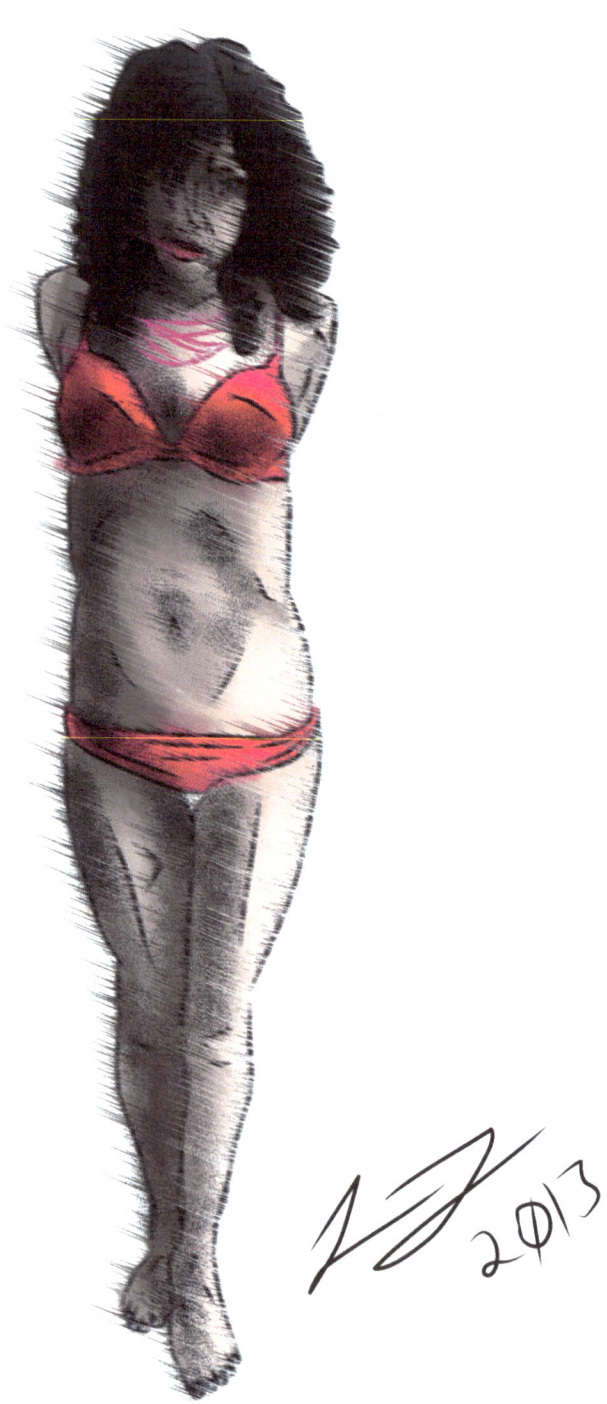

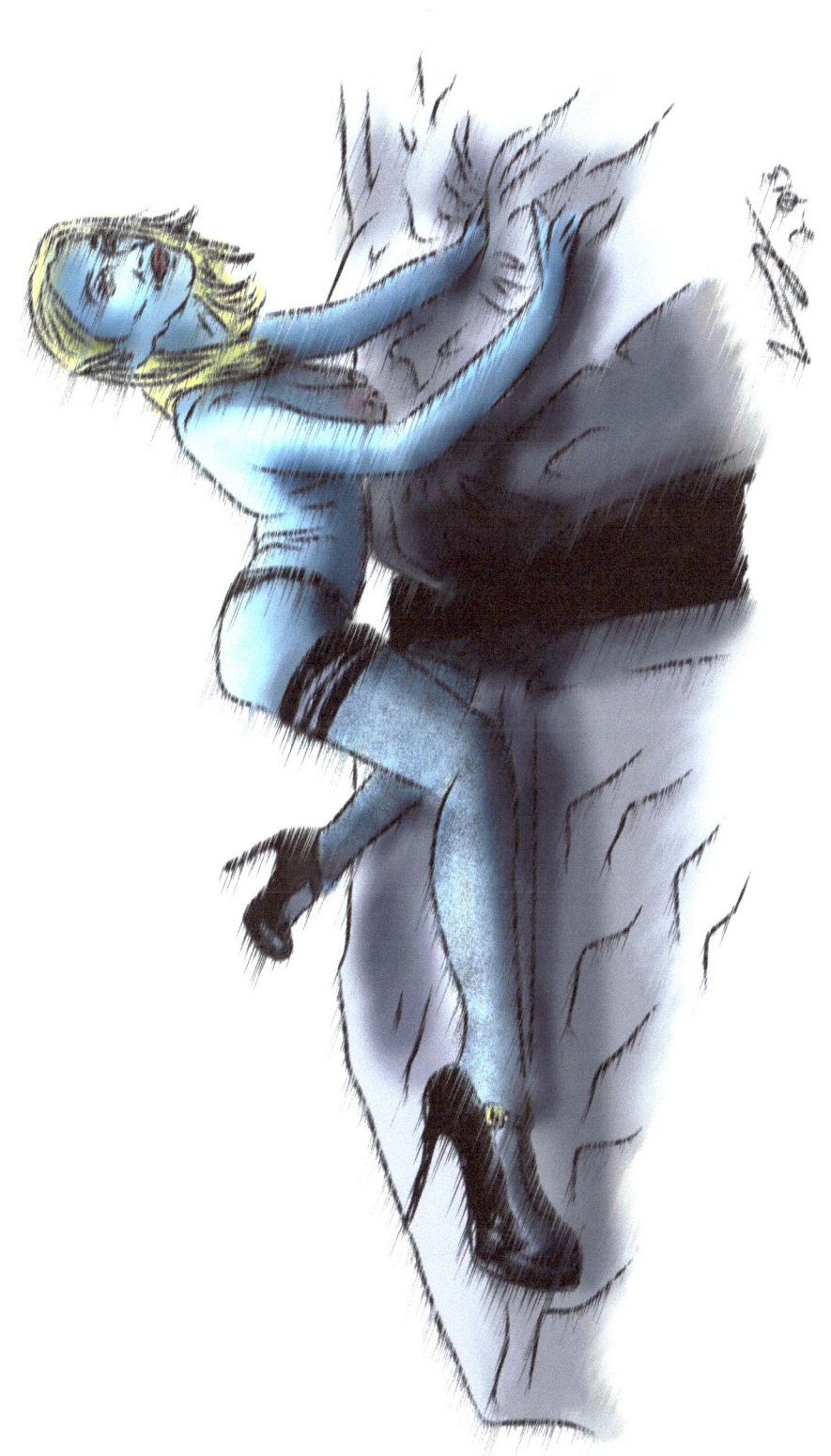

Michelle Trachtenberg

Illustrated by Benjamin Long 2013

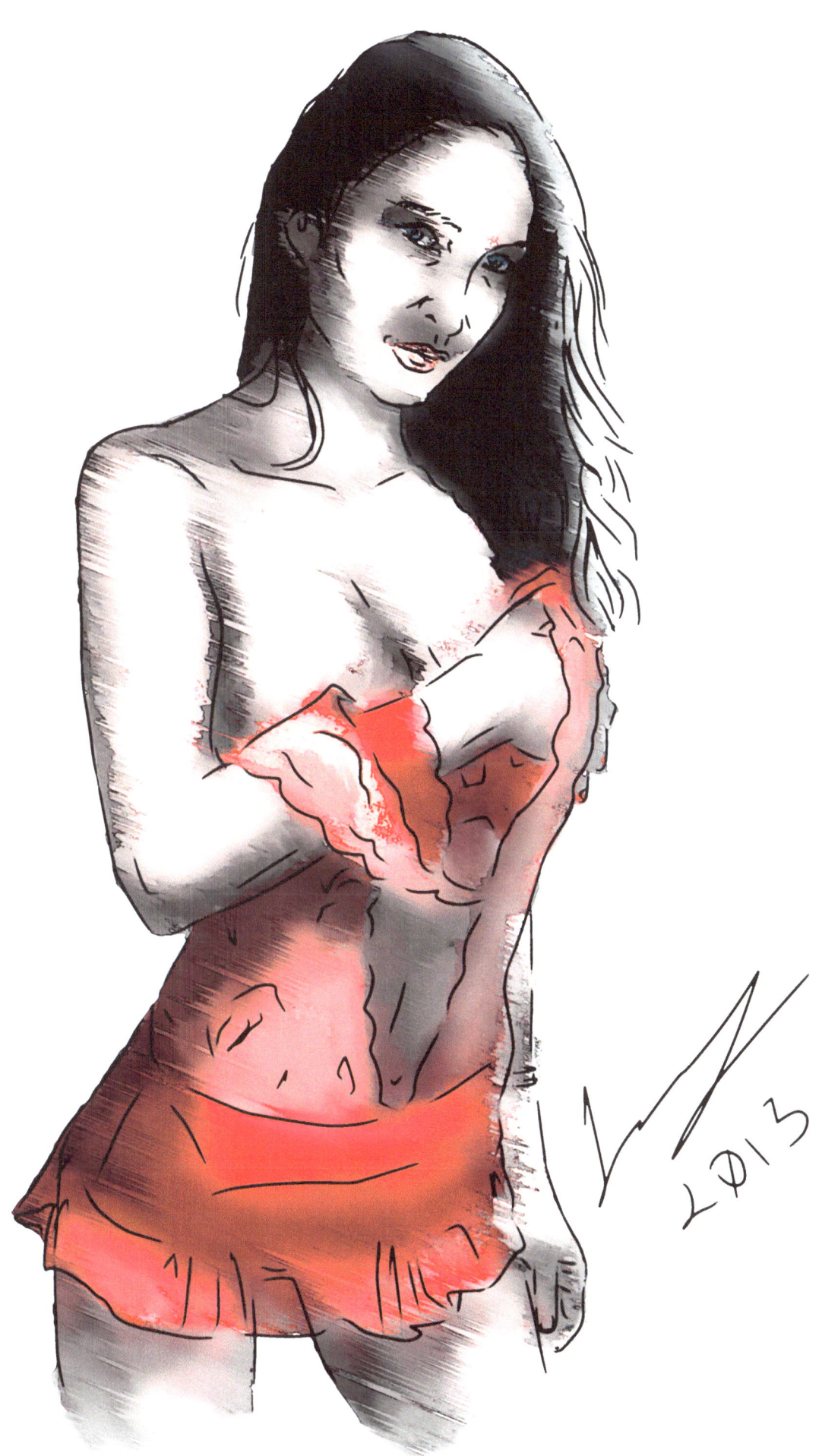

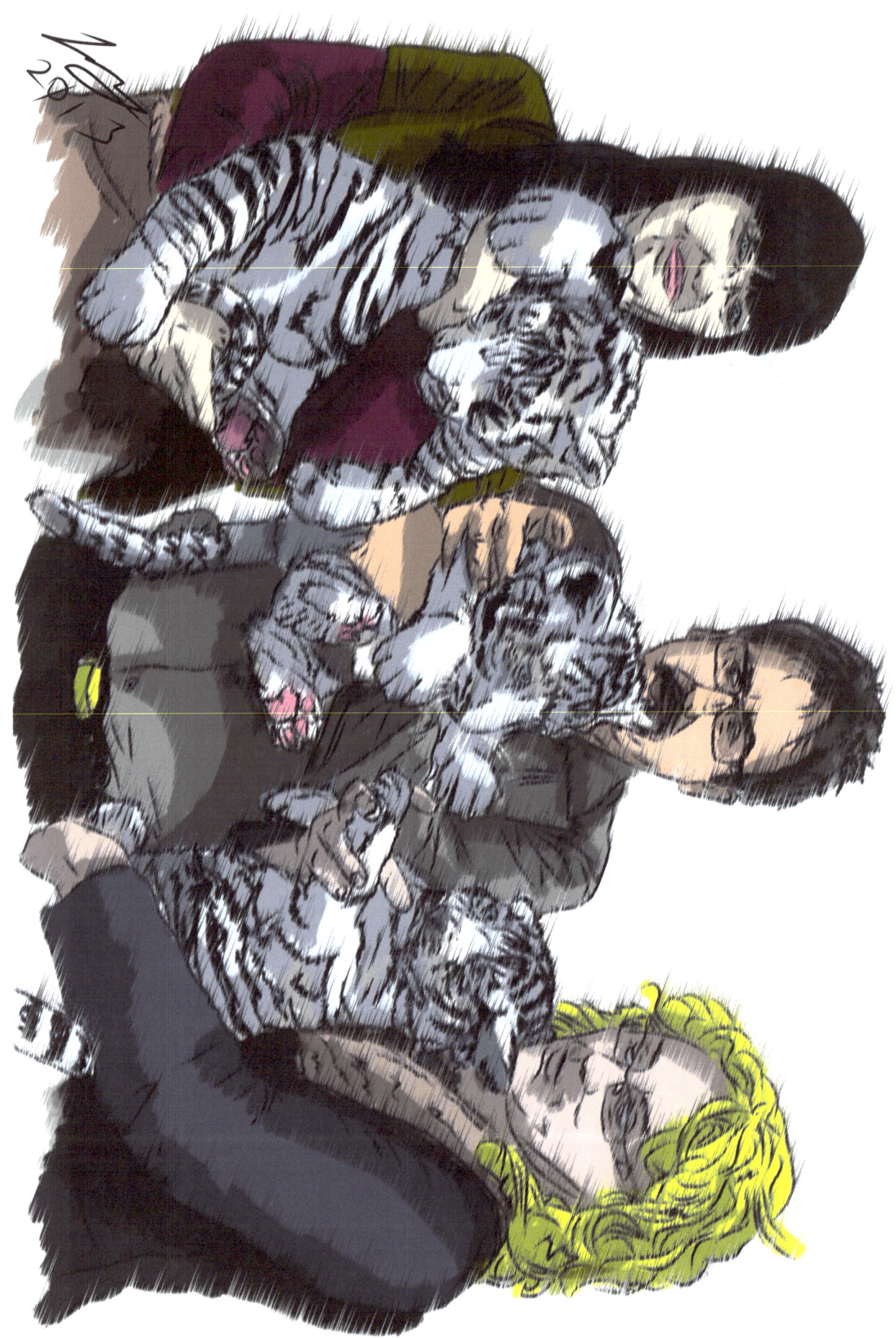

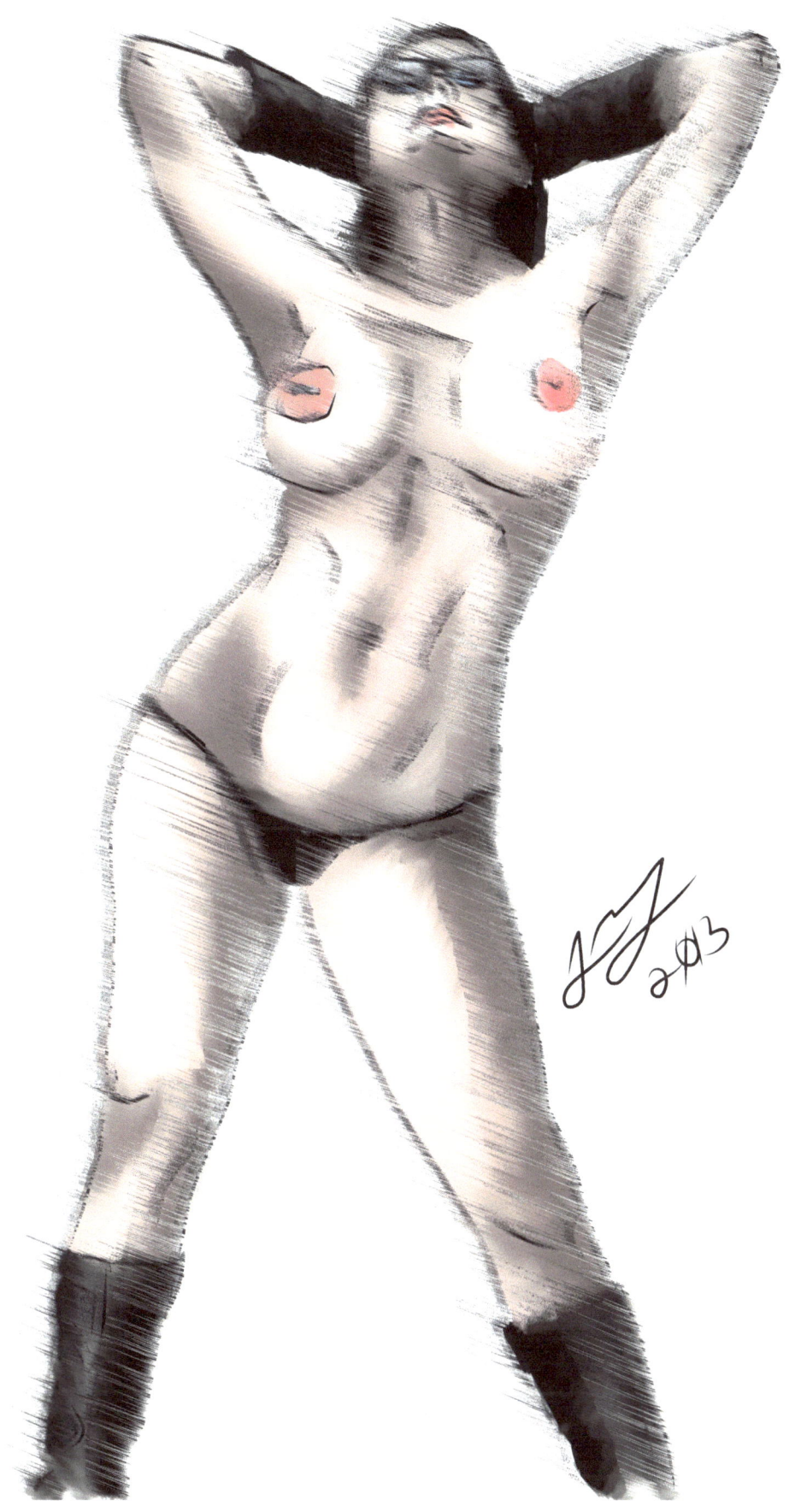

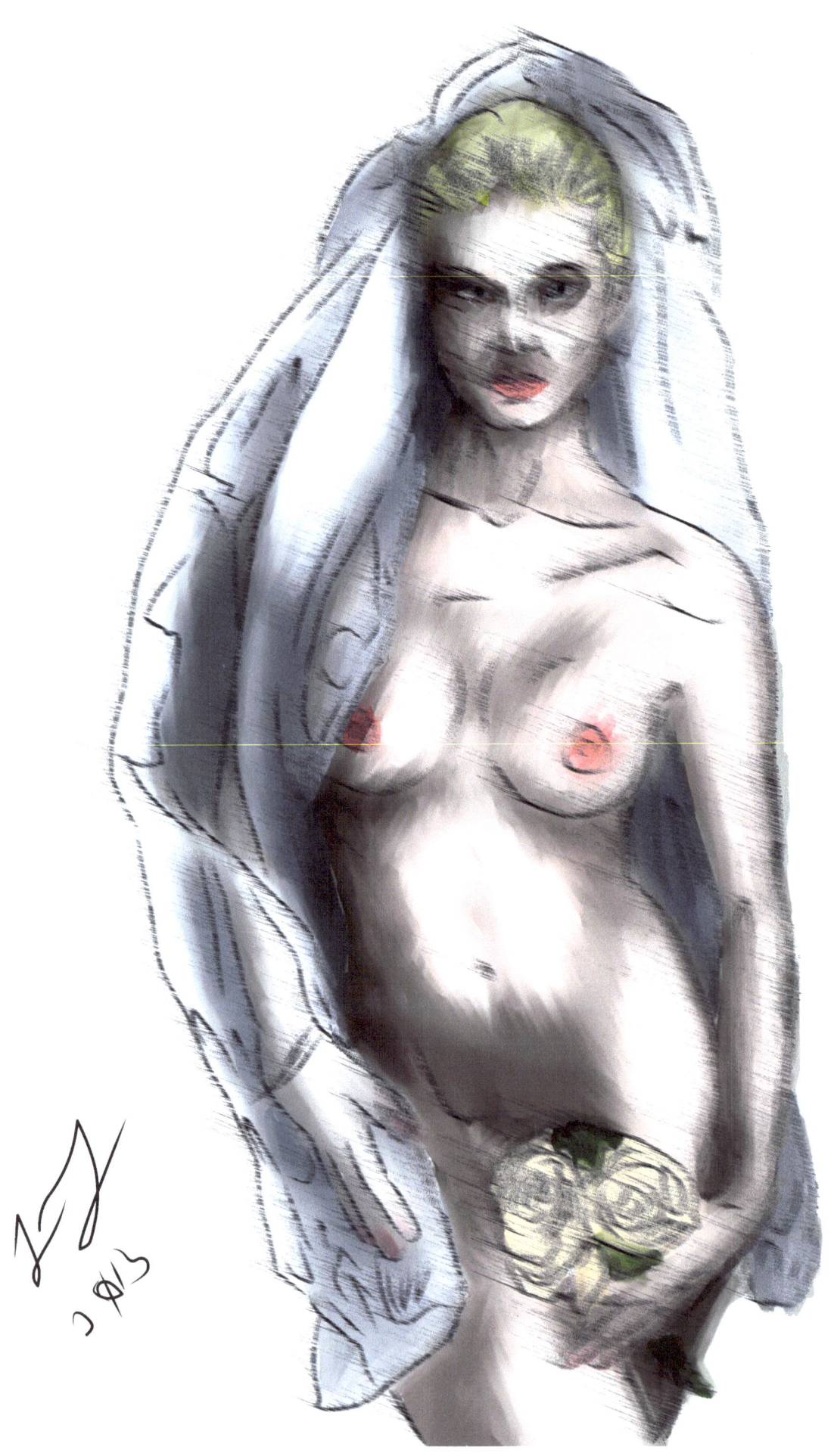

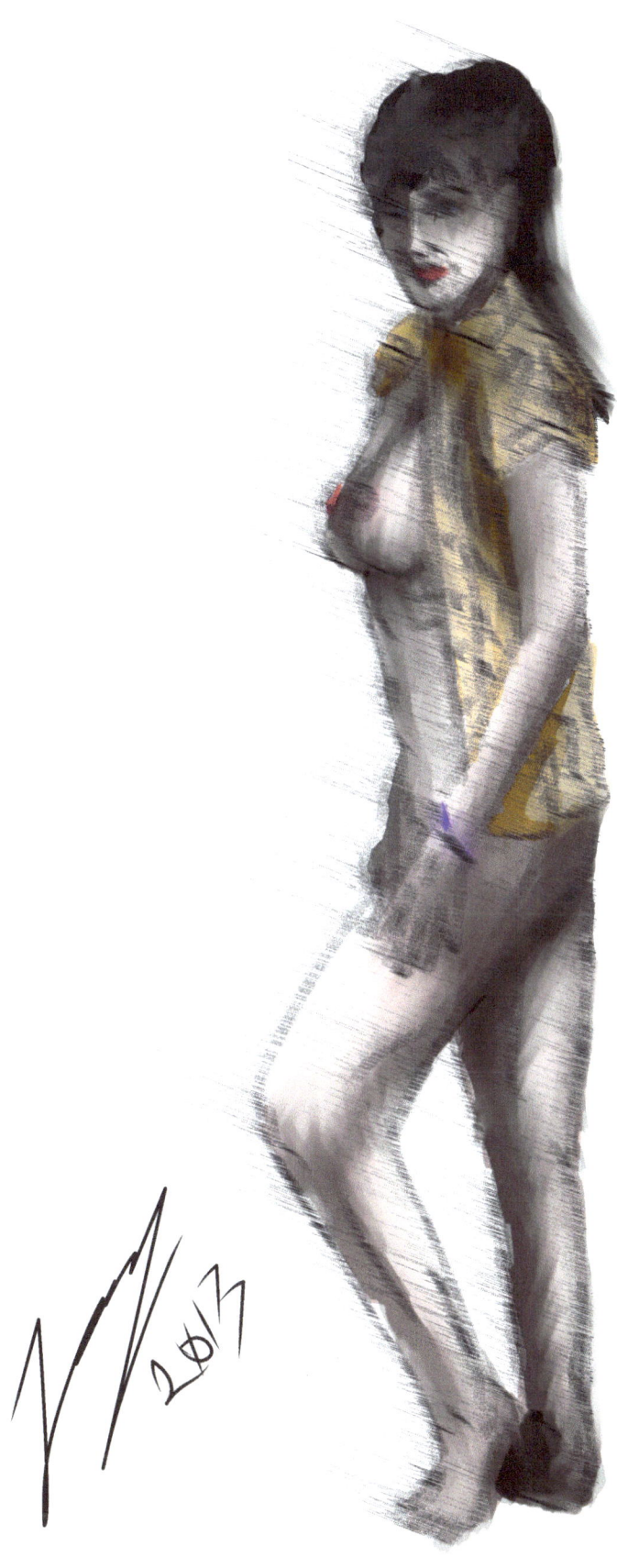

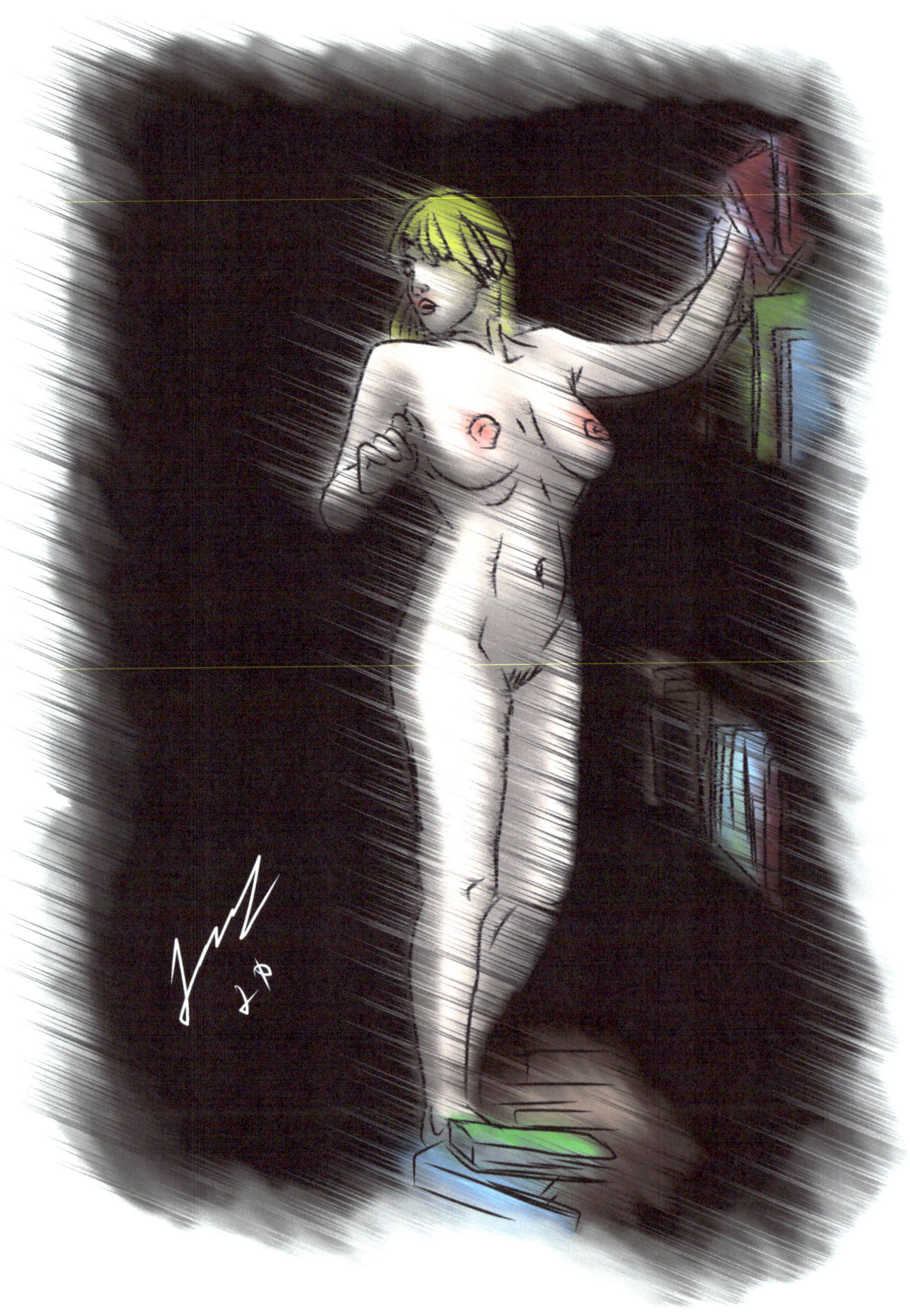

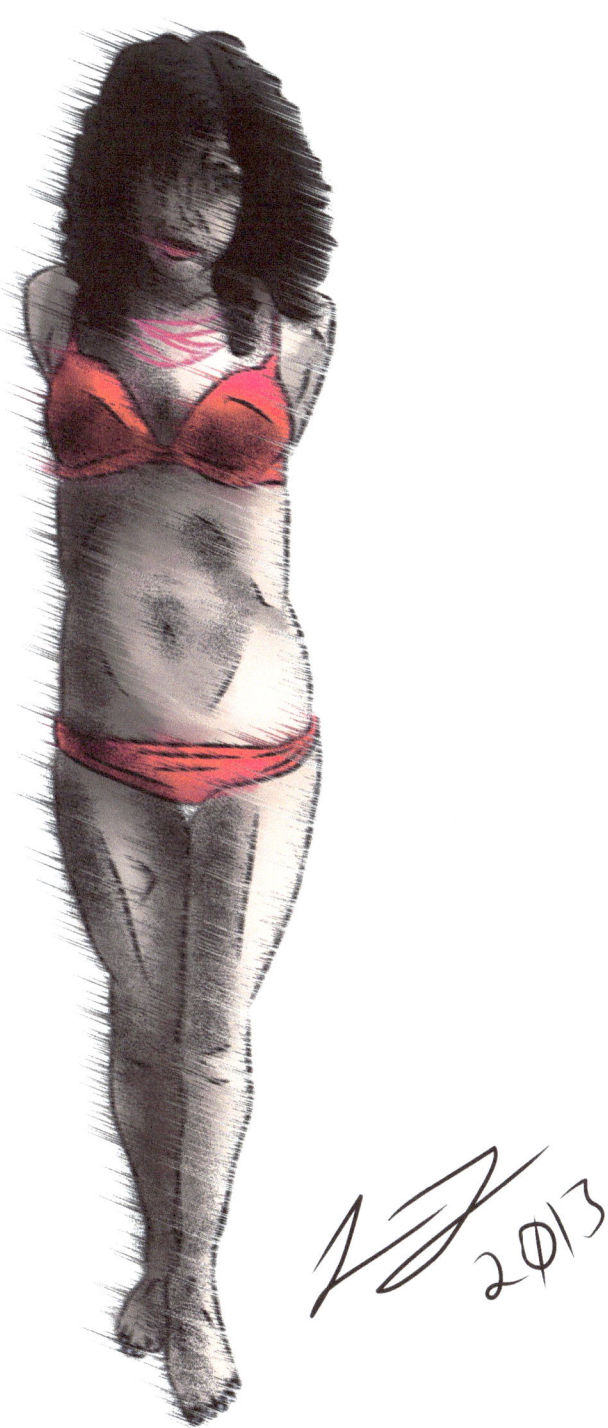

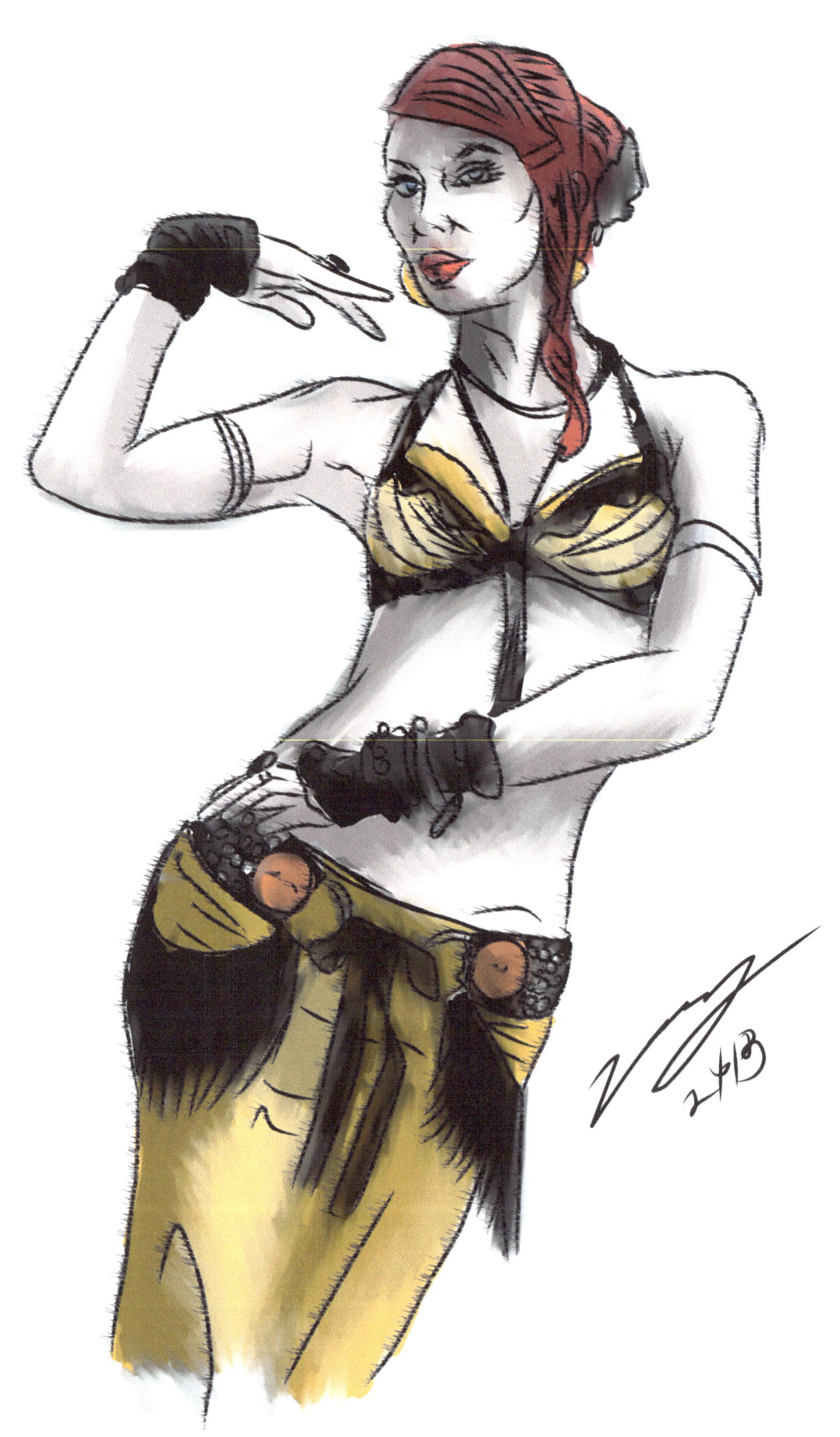

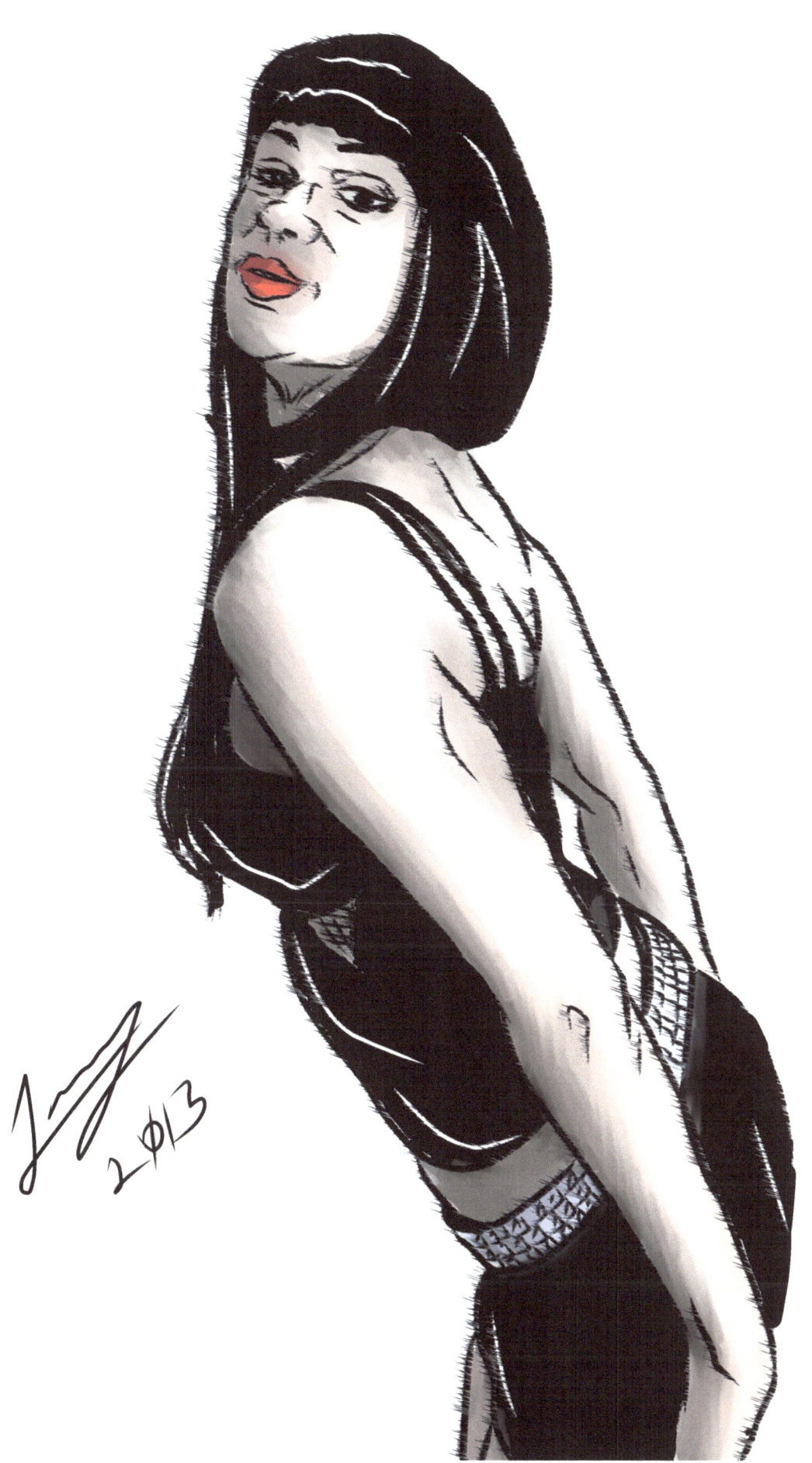

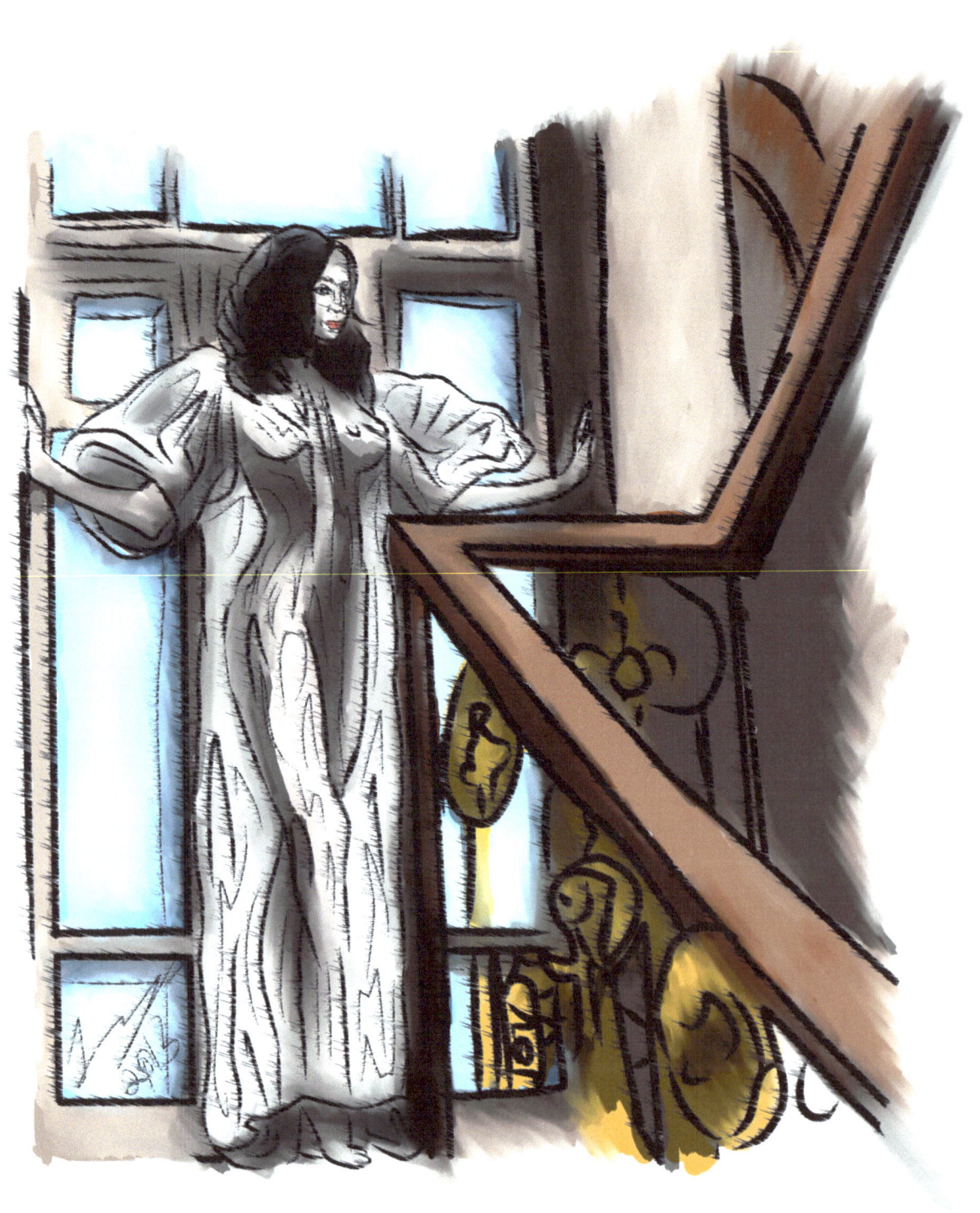

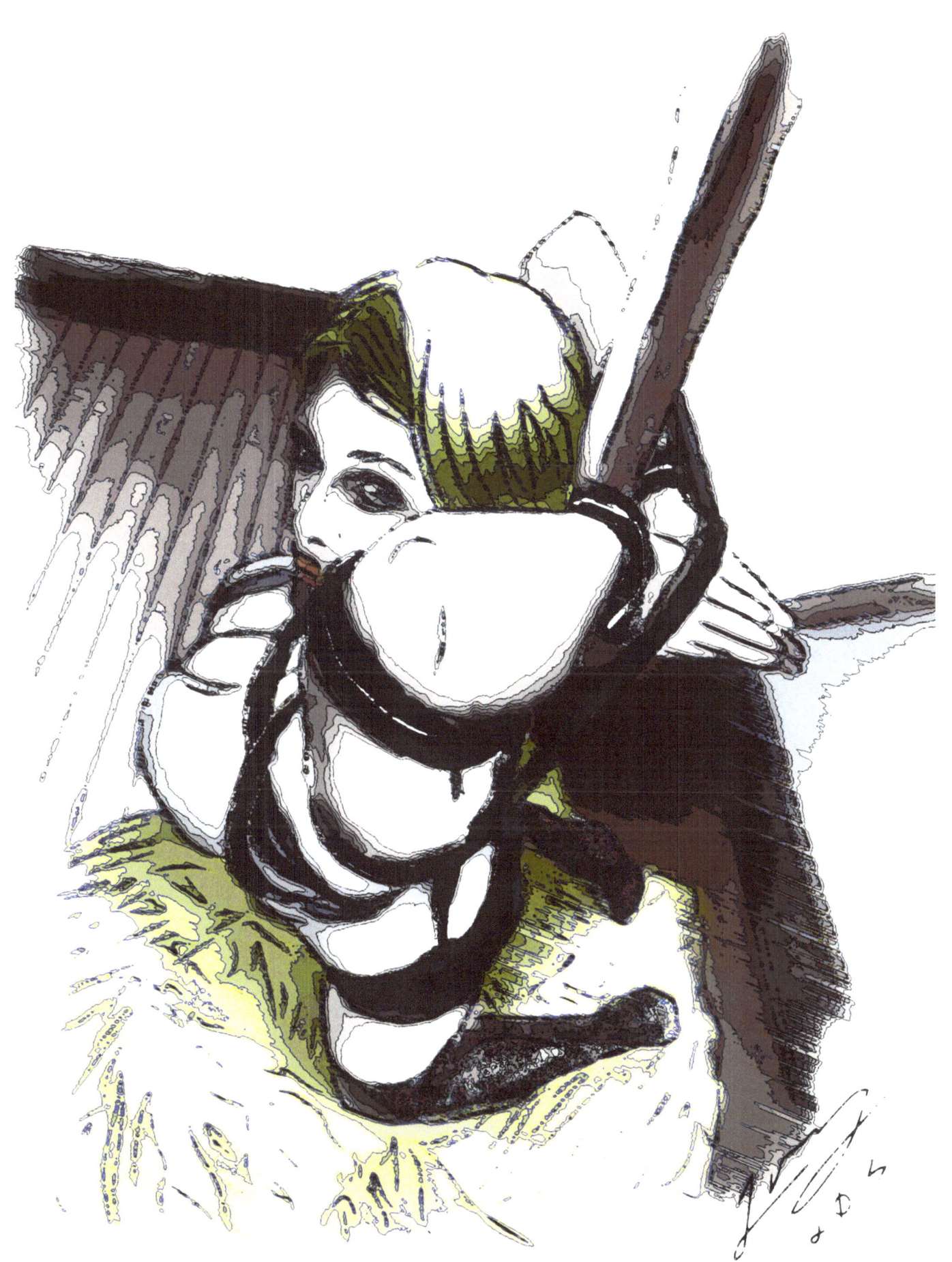

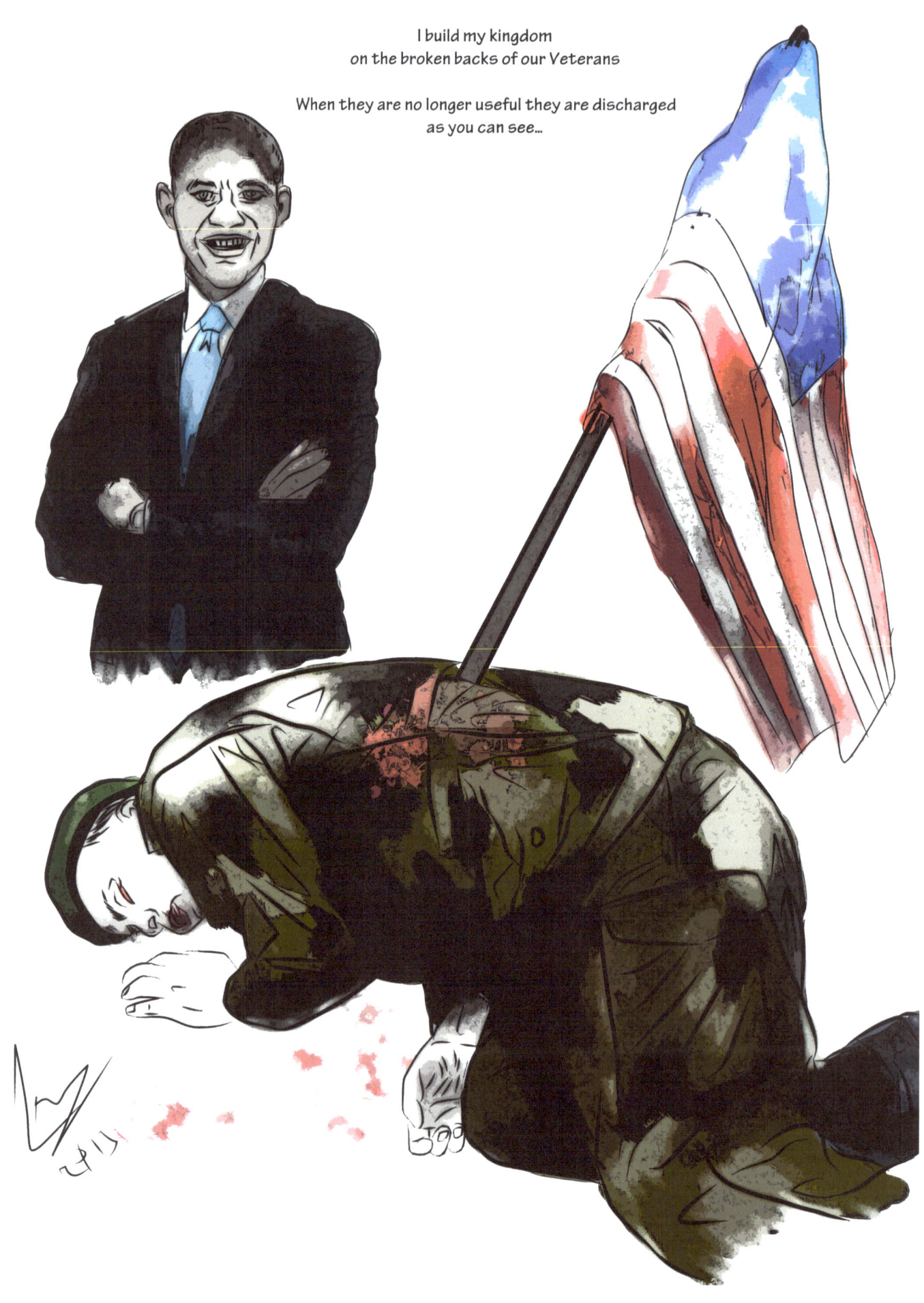

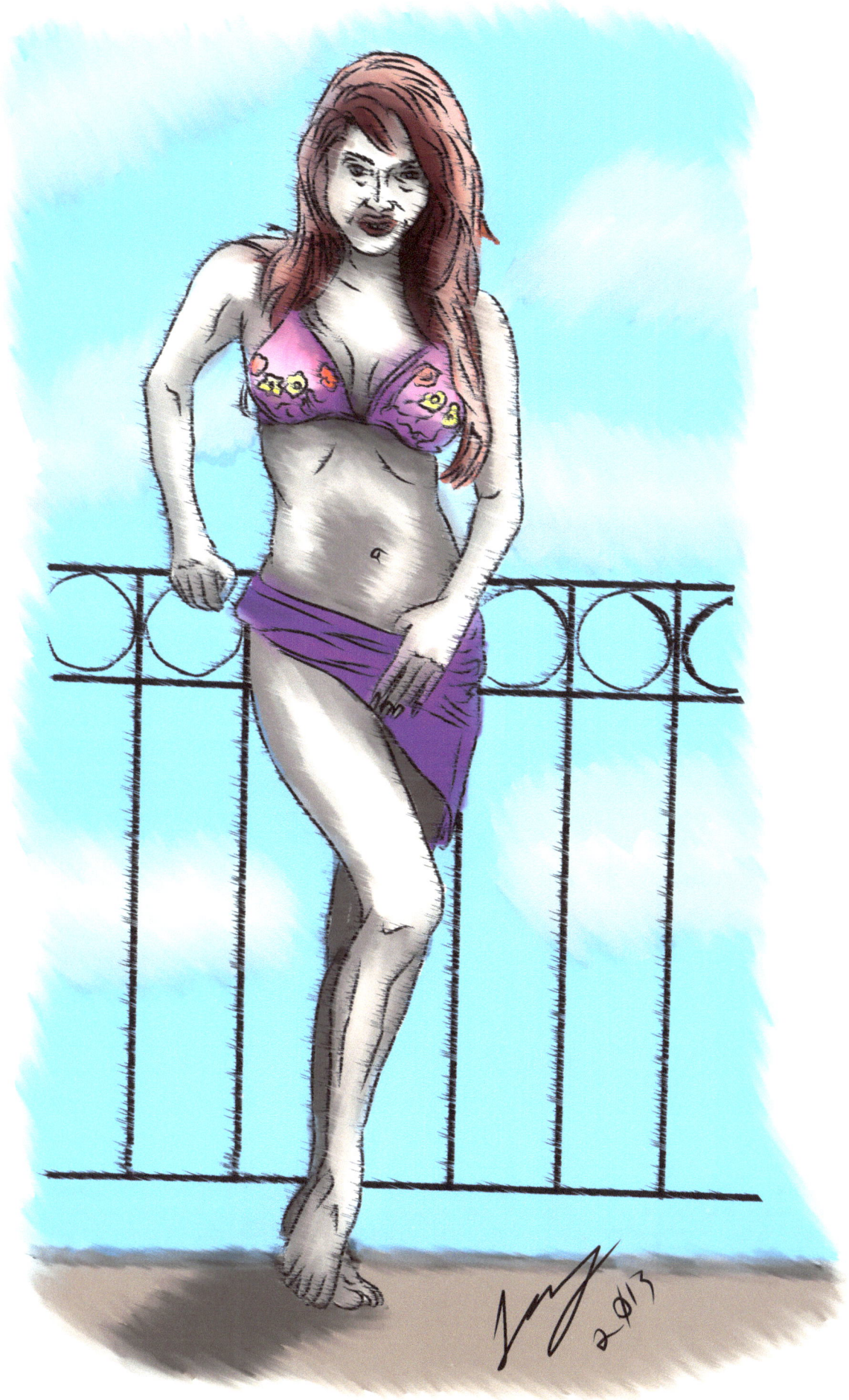

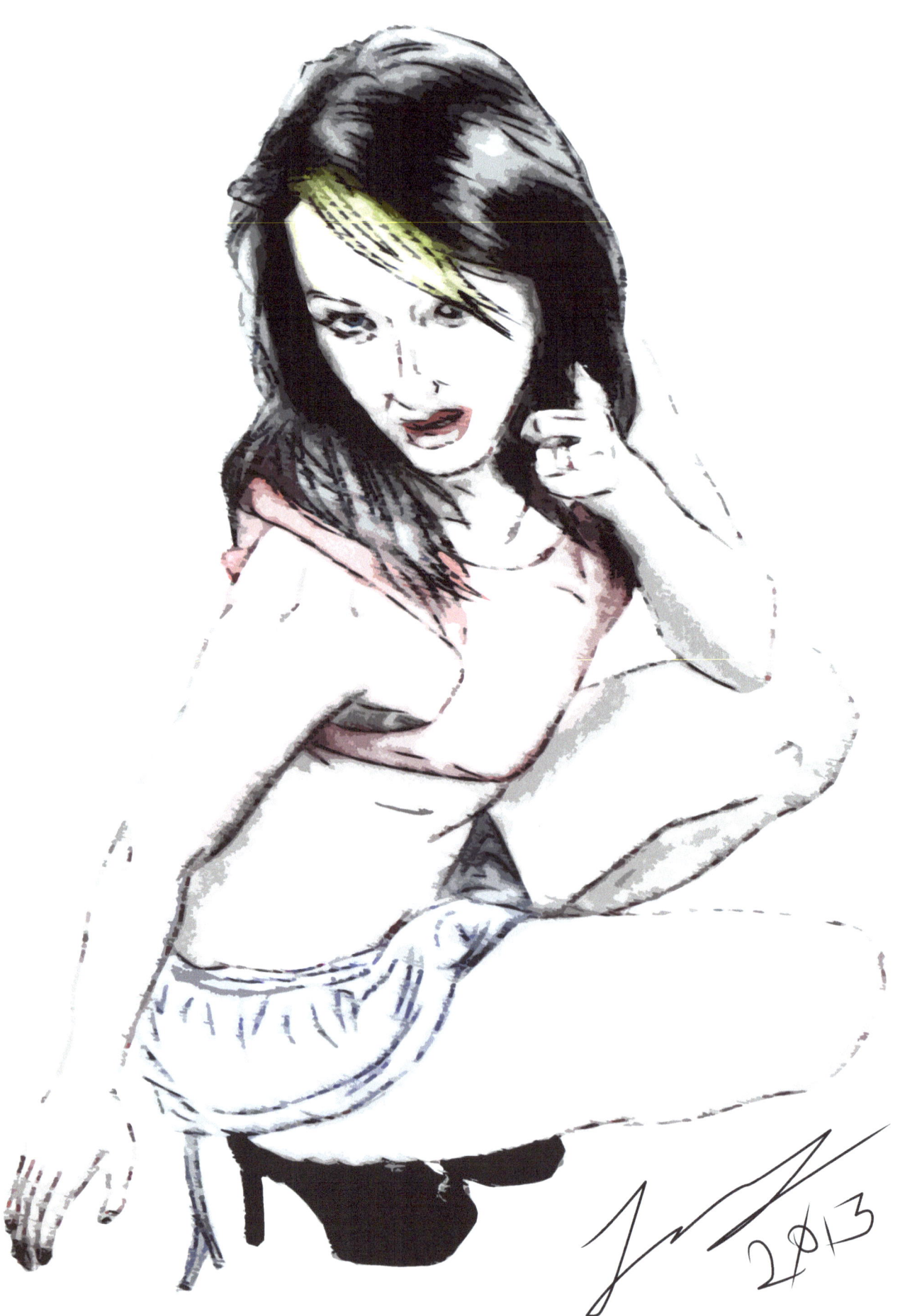

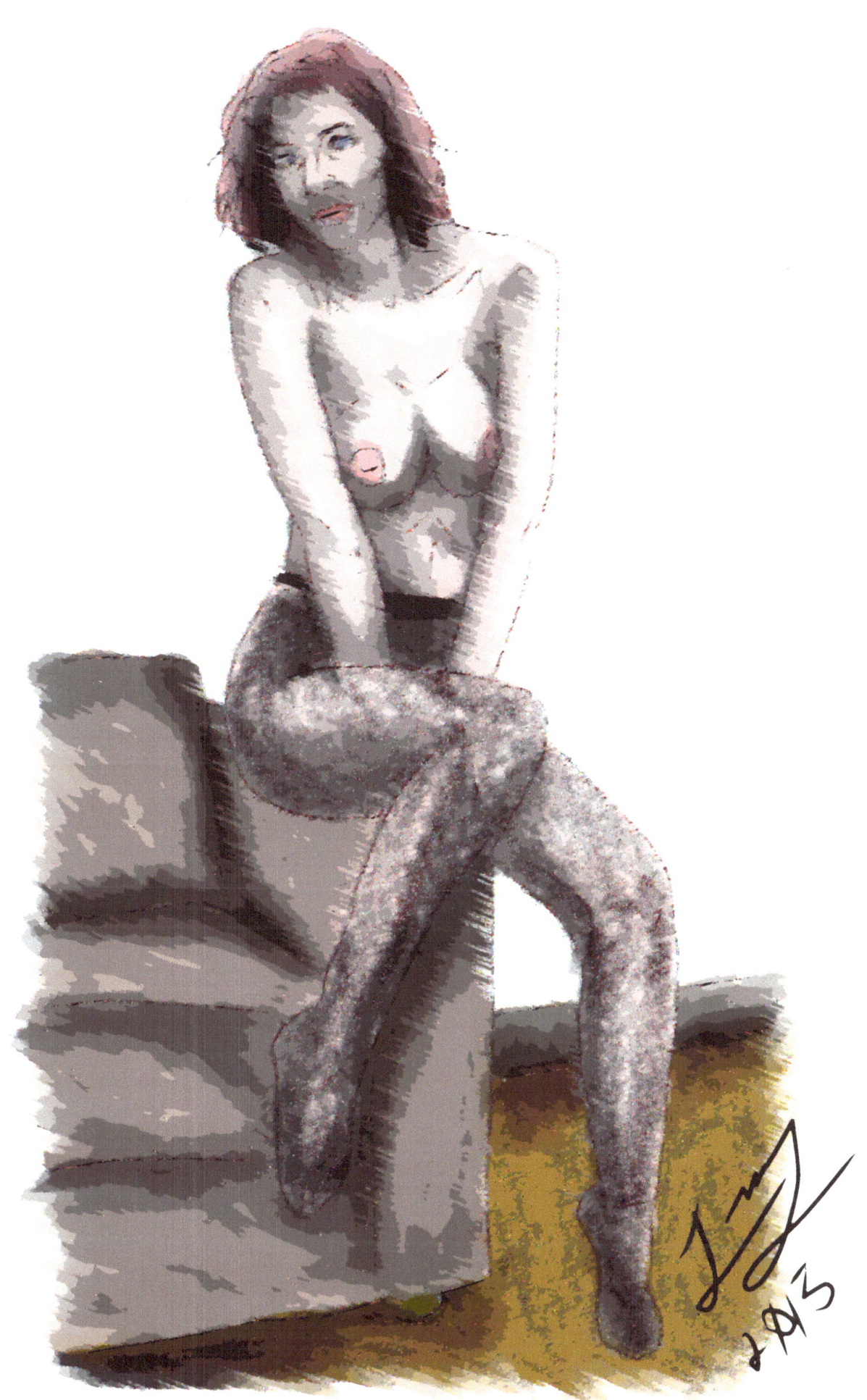

Heathen Art LLC

Benjamin Long, **Illustrator**

The pieces of artwork contained within are the property of Heathen art and Benjamin R Long. No image may be duplicated in part or whole without written permission of Benjamin Long.

Copyrighted images are protected under Title 17 of the USC and traditional copyright applies and duplications must be made in accordance with US law regarding the "Fair use " clause.

Benjamin Long may be contacted on the following Forums:

E-Mail: wiking88142001@yahoo.com

Skype: whitewolfheathen

http://whitewolfheathen.deviantart.com/

Copyright © 2013 (Benjamin Long): All rights reserved.

Commission rates :

Rough Sketch $8 USD

Digital Drawing/Painting $25 USD

Traditional Drawing/Painting on Canvas Panel 8x10 $35 USD

Traditional Drawing/Painting on Canvas Panel 16x20 $80 USD

www.ingramcontent.com/pod-product-compliance
Lightning Source LLC
Chambersburg PA
CBHW051108180526
45172CB00002B/829